DRAWING MASTERCLASS
Copyright © 2010 Page One Publishing Pte Ltd

First published in the United States of America in 2014 by
Rockport Publishers, a member of
Quayside Publishing Group
100 Cummings Center
Suite 406-L
Beverly, Massachusetts 01915-6101
Telephone: (978) 282-9590
Fax: (978) 283-2742
www.rockpub.com
Visit RockPaperInk.com to share your opinions, creations, and passion for design.

10 9 8 7 6 5 4 3 2 1

ISBN: 978-1-59253-933-8

Published in 2010 by
Page One Publishing Pte Ltd
20 Kaki Bukit View
Kaki Bukit Techpark II
Singapore 415956
Tel: [65] 6742 2088
Fax: [65] 6744 2088
enquiries@pageonegroup.com
www.pageonegroup.com

Images copyright © Ruzaimi Mat Rani
Design and layout copyright © 2010 Page One Publishing Pte Ltd

Editor: Rachel Koh
Designer: Zedy Wiepandy Ng, Zonn Lee

DRAWING
MASTERCLASS

Author
Ruzaimi Mat Rani
Co-author
Ezihaslinda Ngah

Illustrators
Ruzaimi Mat Rani
Mohd. Irwan Mohd. Ishak

DRAWING
MASTERCLASS

Rockport Publishers
100 Cummings Center, Suite 406L
Beverly, MA 01915

rockpub.com • rockpaperink.com

CONTENTS

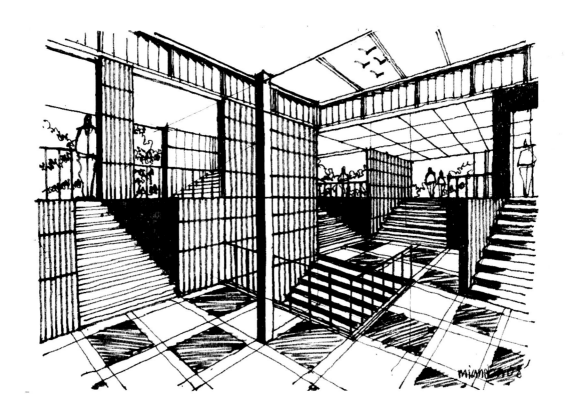

PREFACE

'Don't sketch the scenery that you can see but sketch the scenery that you cannot see.' This is my favourite phrase when I want to write something about the sketching processes.

This book is a compilation of step-by-step processes and selected demonstration videos from my www.freedrawinglesson.blogspot.com web platform. The main objective of this book is to share my knowledge on sketching techniques and processes that I always use to demonstrate on the platform. All written work in this book is based on my opinions and experiences handling the sketching process, and this is only a tiny contribution that I hope may benefit others around the world. I also believe that anybody can draw well if they are exposed to good technique that is easy to handle.

Ruzaimi Mat Rani (miandza)
2009

ACKNOWLEDGEMENT

To be able to realise my dream of publishing this book and to share my knowledge with readers is one of the greatest joys that I have had in my life. Indeed, my deepest gratification goes to all my teachers and others without whom I would not be able to gain as much knowledge about life and the world. My earnest pleasure also goes to my co-author, Noor Siti Sara Nazli, in assisting me by completing the book contents. Of course, my backbone and strength, my family; Aidaliza, my beloved wife who has been with me through thick and thin in supporting my completion of this book; my adorable children, Athirah, and Hazim, my much-loved parents, Haji Mat Rani and Hajjah Maznah; my dearly loved parents in-law, Haji Aga Mohd Jaladin and Hajjah Mahyah, the rest of the family members and my friends. May your unremitting support remain forever.

CHAPTER 1

THE IMAGINARY BOX

What is an imaginary box? Basically, it is a simple box constructed from thin lines and used as a guide to draw objects or scenery in sketches. It is an interesting concept and sketching technique that has been practiced by designers and artists for many years, but seldom discussed in detail. An imaginary box is created from a very thin line using a Vanishing Point (VP) as a reference in creating perspective. This box comes in many different shapes and sizes according to the objects drawn. It is also one of the contributing factors in achieving good proportion in perspective drawing.

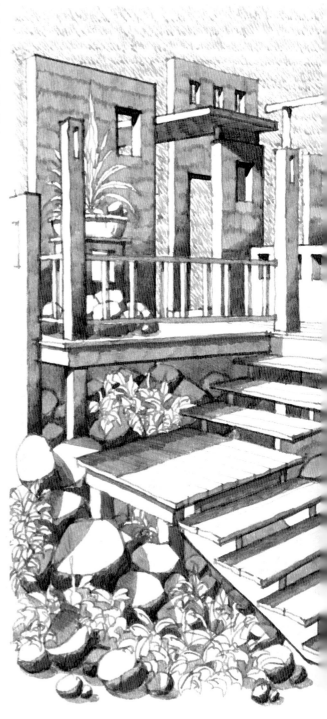

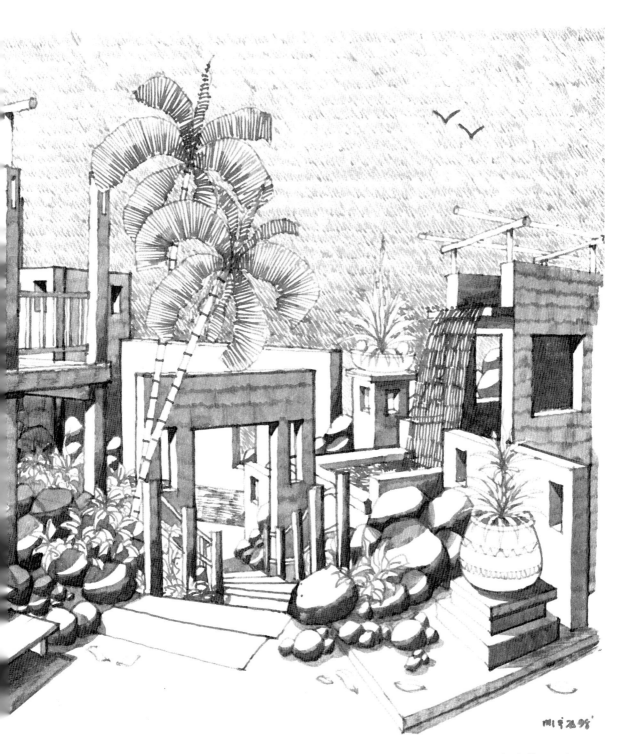

Sketch No.54 from 'The Sacred Garden', a collection of 85 pieces. Sketched by Miandza in 1999

These are some examples of one point perspective settings
constructed using the imaginary box.

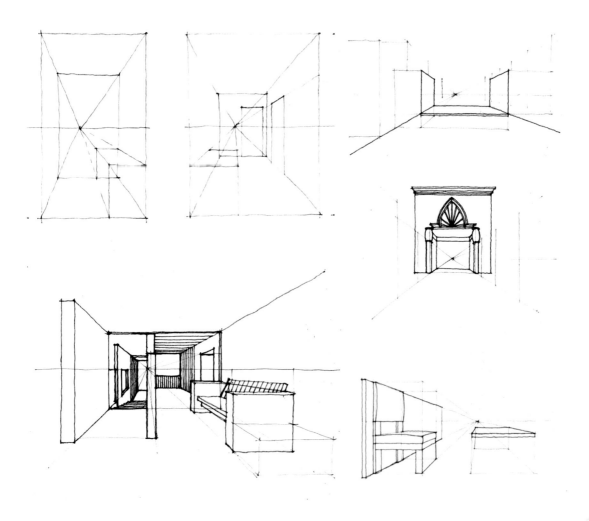

Imaginary boxes may come in many different sizes depending
on the type of objects or setting.

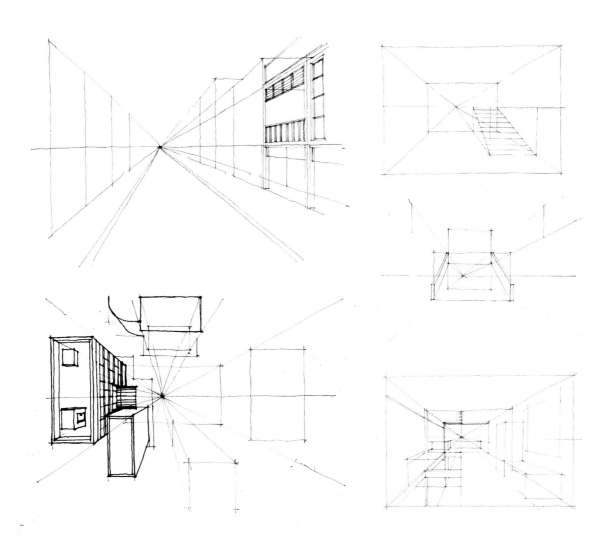

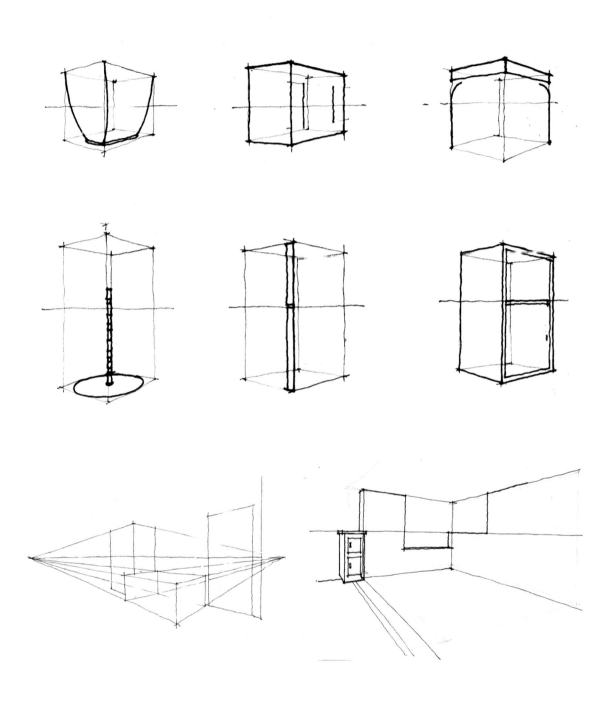

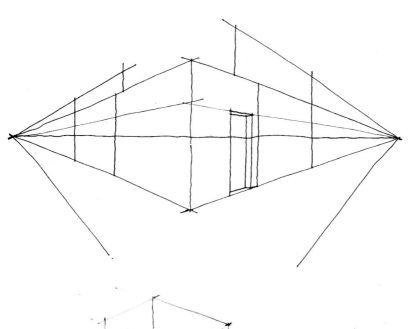

A two point perspective constructed with the imaginary box can also create many interesting compositions such as these.

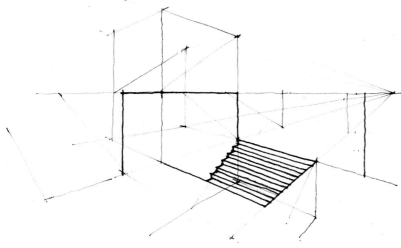

It also helps to deal with multiple levels and planes in perspective where most find difficult or complex.

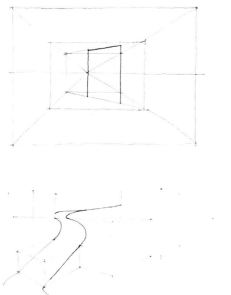

Similarly, one is able to visualise and execute multi point perspectives. These are a few examples.

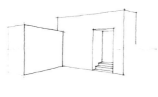

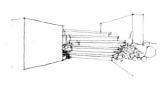

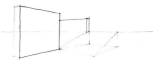

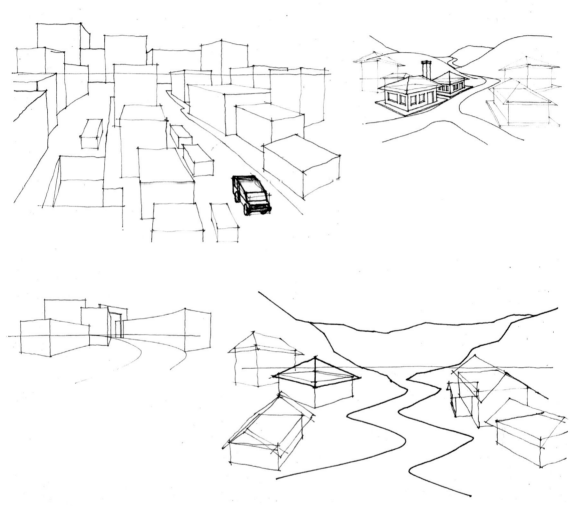

These are possible composi-
tions for multi point perspec-
tive drawing including urban
and rural areas and scenes.

THE PROCESS

Everyone can draw well if they are exposed to the right drawing techniques. The imaginary box concept is not new and has been applied extensively for many years by designers and artists around the world.

The next few chapters are divided into the following categories:
• One point perspective
• Two point perspective
• Multi point perspective

The techniques employed in this book are not the ultimate way to sketch but they are useful and should be shared with others. Hopefully, they enable one to create more interesting and varied compositions.

Step by Step: One Point Perspective

Below is a step-by-step process where the imaginary box has been used to create an interesting one-point perspective setting. Observe them as they illustrate how you can improve your sketching skills.

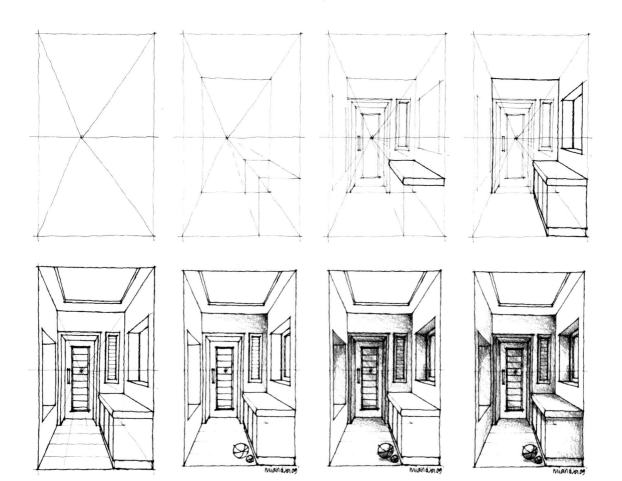

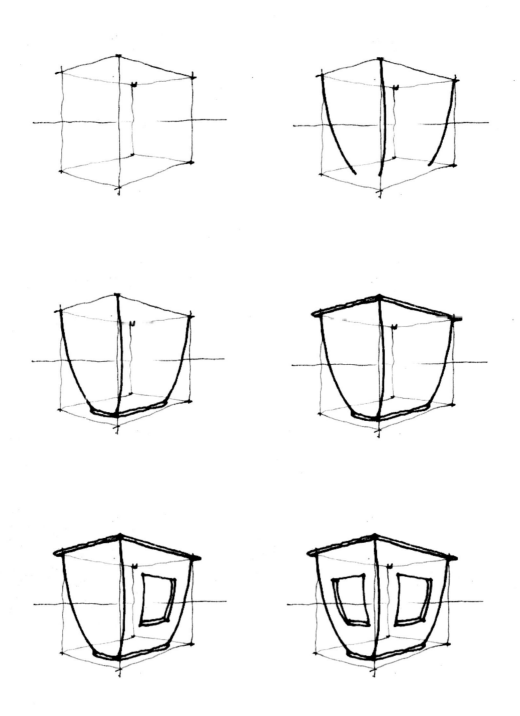

Step by Step: Two Point Perspective

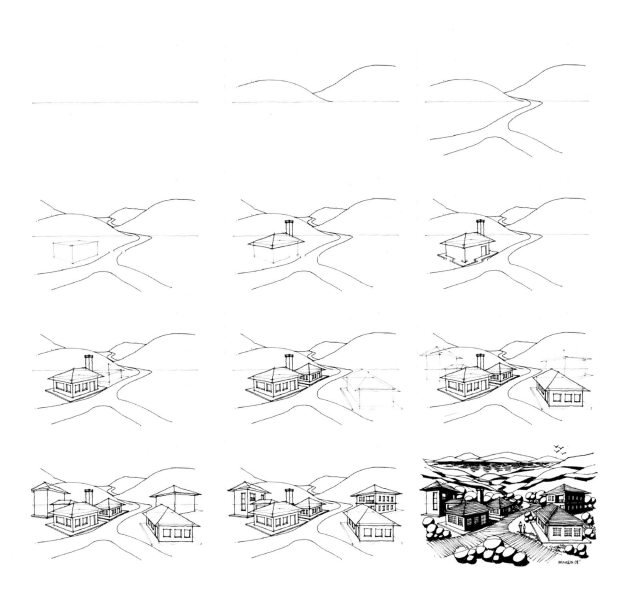

Step by Step: Multi Point Perspective

CHAPTER 2

THE IMAGINARY BOX IN ONE POINT PERSPECTIVE

Let us start our exploration with a one point perspective sketch. A good three-dimensional sketch requires a perspective approach that is the simplest to handle. It can be applied to interior and exterior spaces such as in rooms or in street compositions. How do we create a one point perspective? We must understand that it consists of one vanishing point located at the horizon line (eye line) that determines our view within the composition.

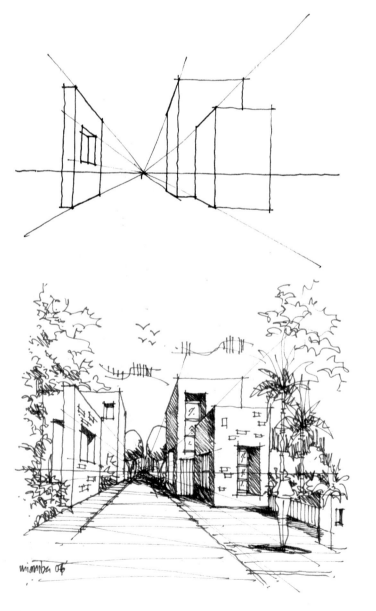

This is a sketch created with the imaginary box in a one point perspective.

The final sketch composition with pen rendering.

INTERIOR PERSPECTIVE : ROOM (A)

These sketches follow the process of making a simple and narrow room using the imaginary box in simple and manageable steps.

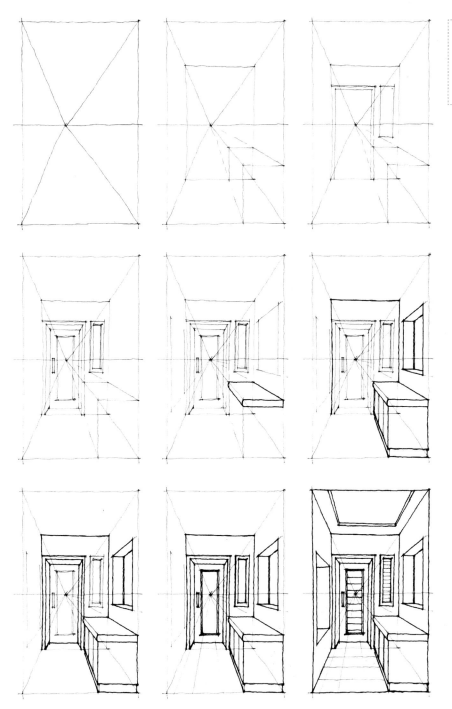

Tip 1: Always remember to use the imaginary box to help you when sketching.

This is the final sketch of a simple and narrow room. It looks proportionate and the composition is interesting.

Art Marker Rendering

It is great to use art markers for rendering but they are often quite an expensive option. Observe the effectiveness of the colouring and shadow casting of the room.

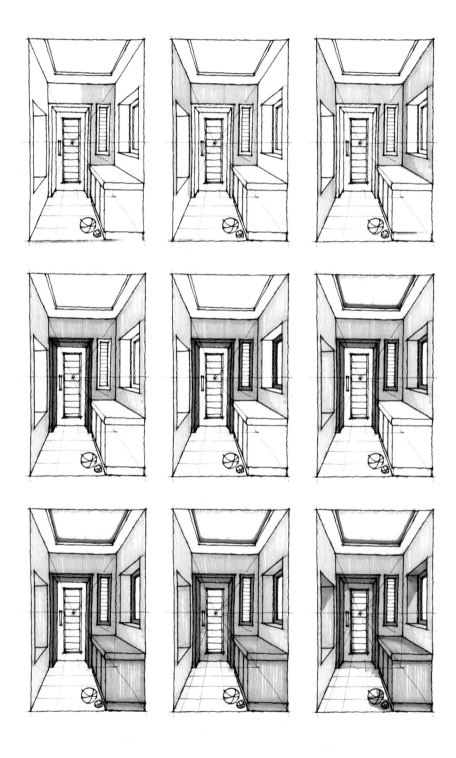

Pencil Rendering

Pencil rendering is a favourite technique used by many to get fast results. Normally, a graphite pencil ranging between B to 6B is used, depending on the thickness and depth that is desired.

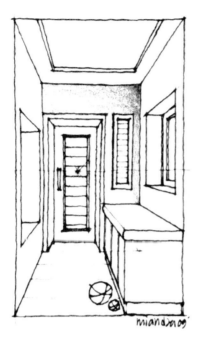
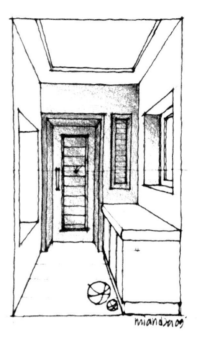

Usually, the rendering process starts from the background and continues to foreground surfaces in the composition. The rendering process applied is based on the 'shade and shadow' concept where the light source needs to be determined.

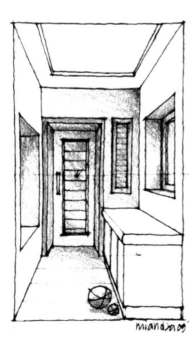
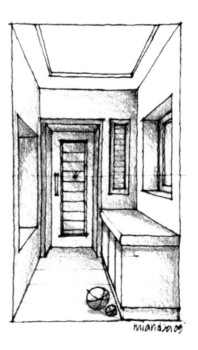

INTERIOR PERSPECTIVE : ROOM (B)

This is another example of a room sketched using the one point perspective approach.

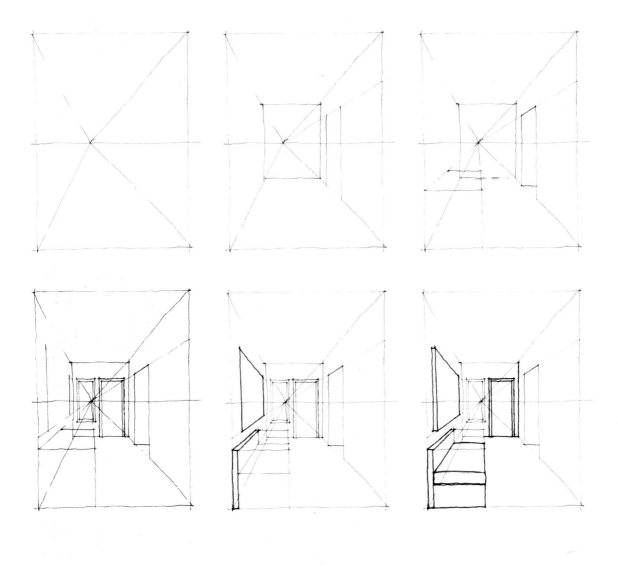

Observe these three sketches and how the primary elements such as the wall, sofa, painting and racks were sketched first in their respective positions.

Then, proceed with the secondary elements such as the floor tiles and ceiling before introducing more details.

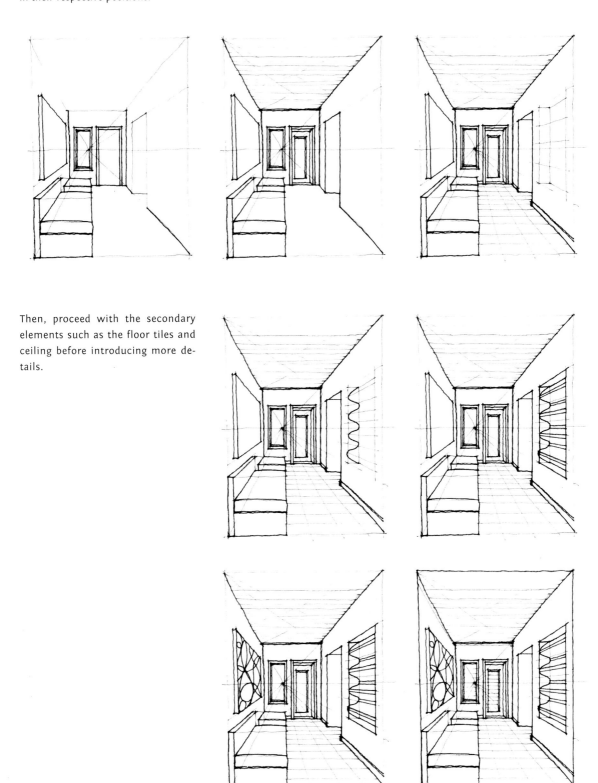

Art Marker Rendering

Always apply soft colours to the first layer before doing so with stronger colours in the subsequent layers during the rendering process.

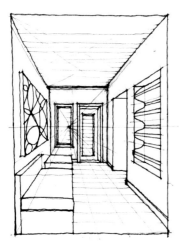 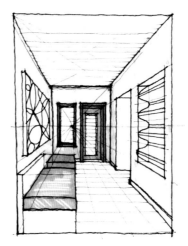 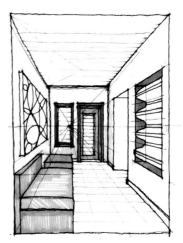

You can also leave out a few white spots in the sketch to make the composition more interesting and unique.

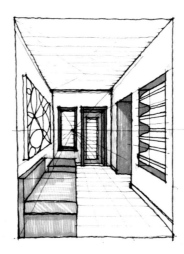 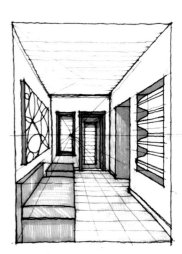

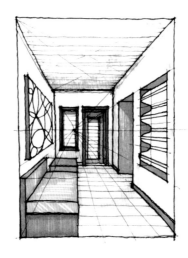 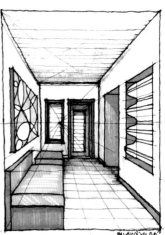

Pen Rendering

Observe how the hatching technique has been applied to render this sketch.

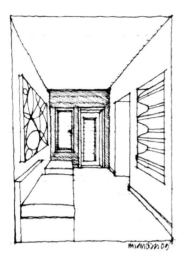
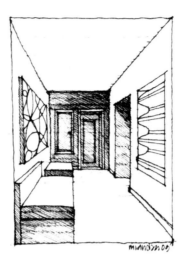
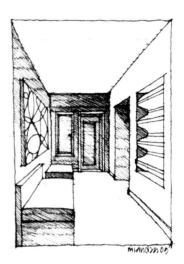

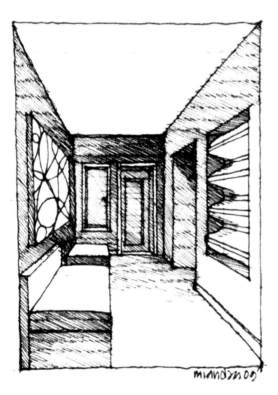
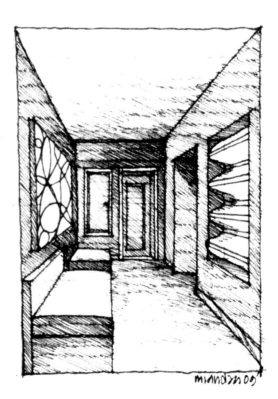

Here, the concept of 'shade and shadow' has been applied to the sketch, creating more depth and an appealing ambience.

A ROOM

The following sketches demonstrate how the size and scale of objects influence the setting of the eye level. In this example, it is a child's eye level that has been set.

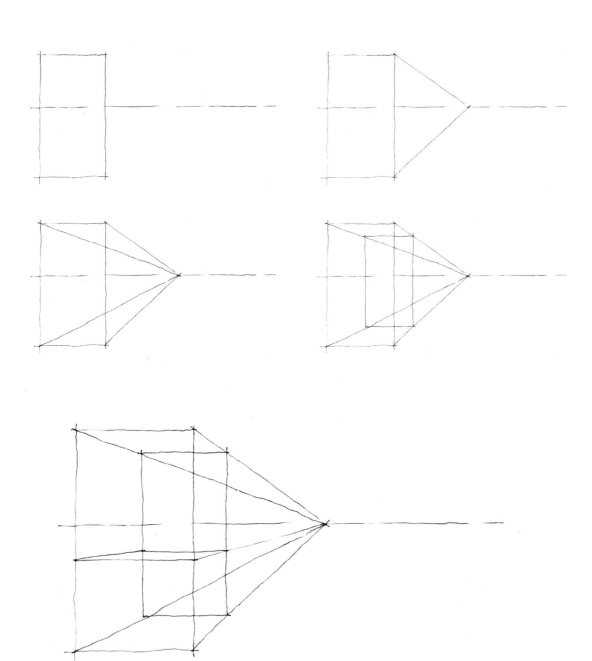

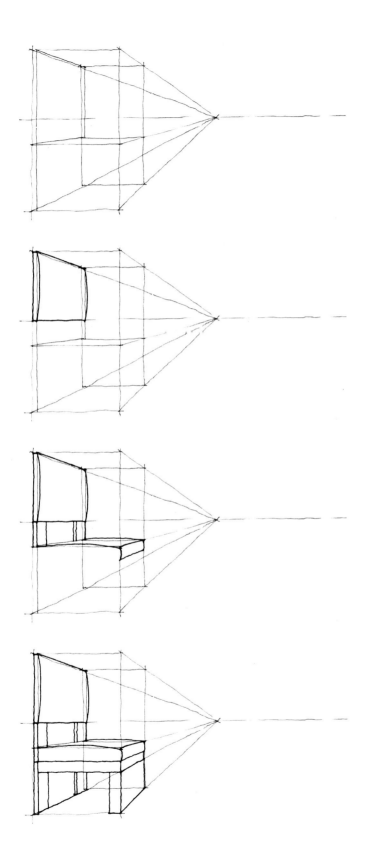

You will notice that this object influences the scale and proportion of the view in relation to horizon line (eye level).

Tip 3: *Always have an in-depth understanding of the imaginary box and its relationship with the horizon line before applying it.*

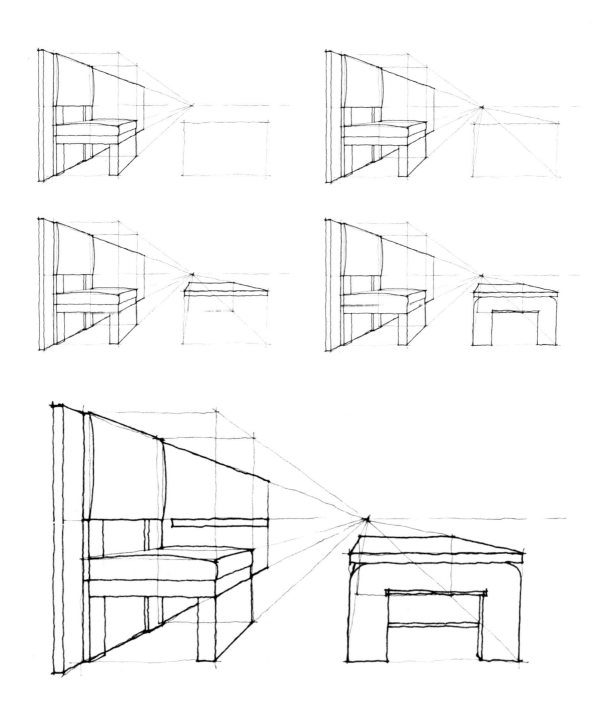

Then, sketch other elements based on the chair's scale and proportion. In other words, the chair becomes the reference point for the composition.

The same process applies to other objects introduced.

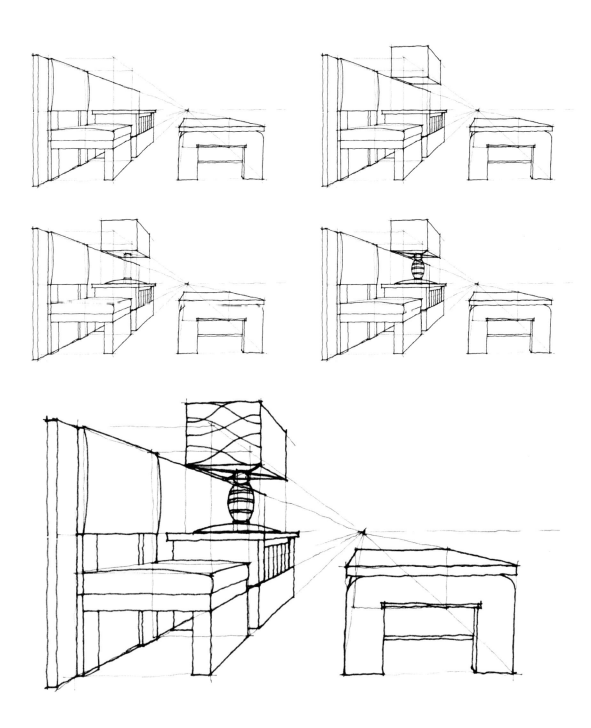

By connecting all the perspective lines to the vanishing point, the imaginary boxes are drawn to the right size and proportion; it results in a pleasant-looking composition.

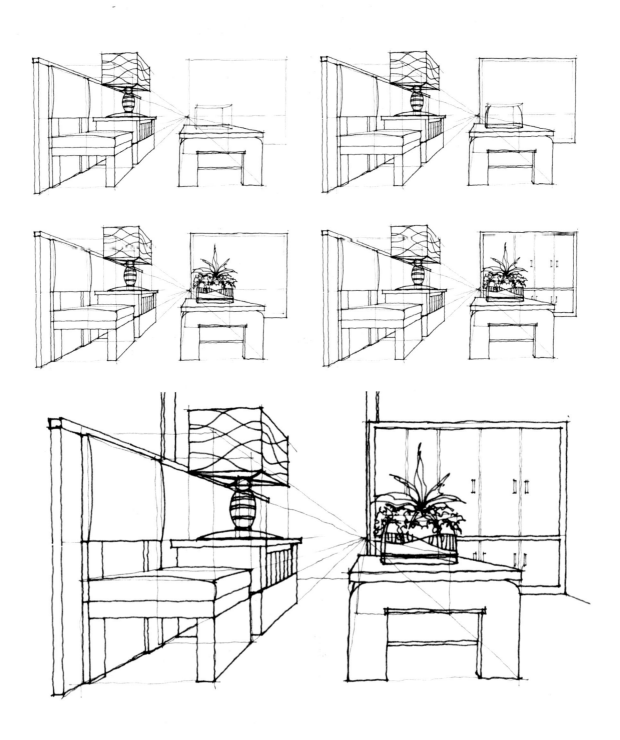

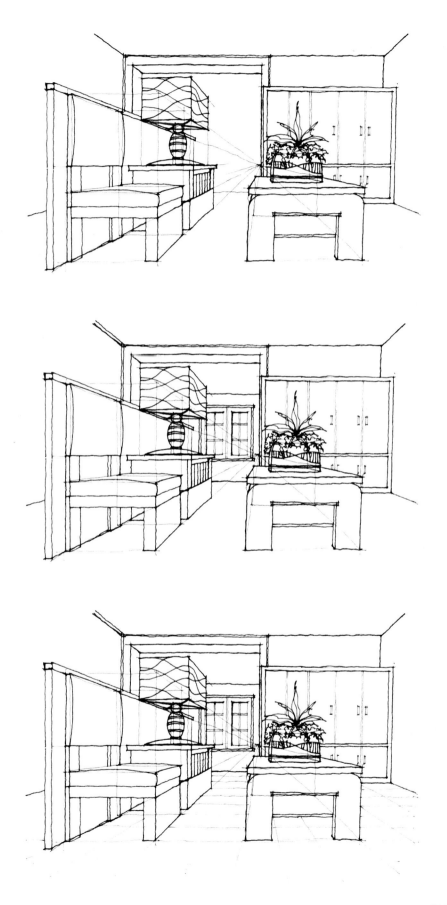

Art Marker Rendering

Start the rendering process by colouring the free standing wall by the chair and the side table. This is to differentiate it from the larger wall behind it.

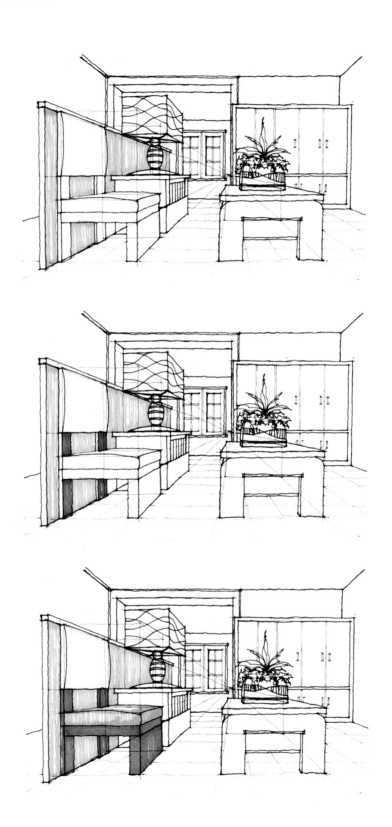

Continue colouring major objects such as the chair, side table and coffee table.

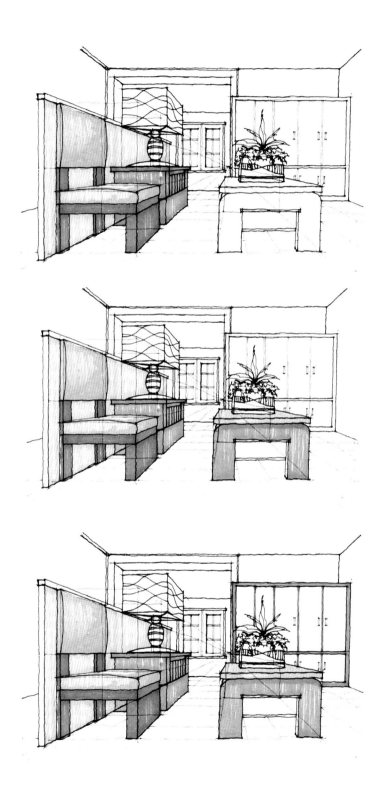

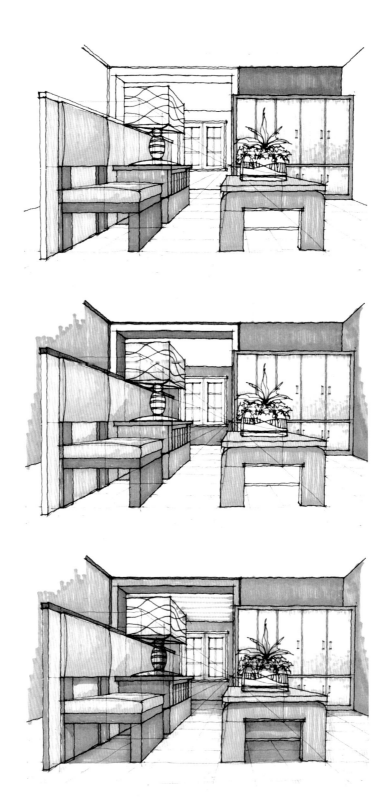

Lastly, apply shades and shadows as a final touch. This needs to be done carefully especially for shadow casting as it is easy to interfere with the colours applied previously. A grey marker should be used for best results.

Pencil Rendering

A grade 5B pencil can be used to achieve a 'soft' effect for rendering.

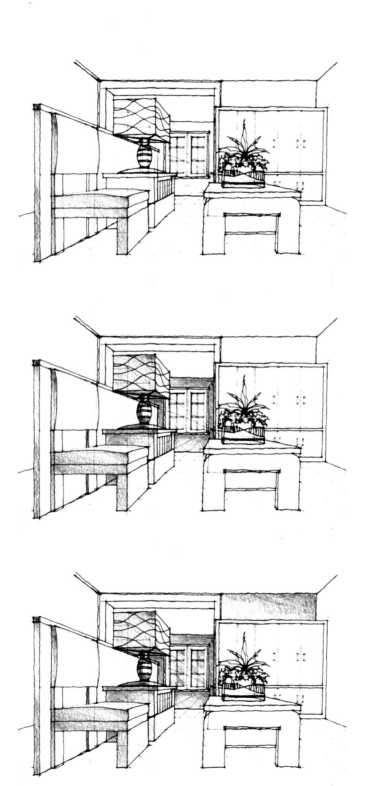

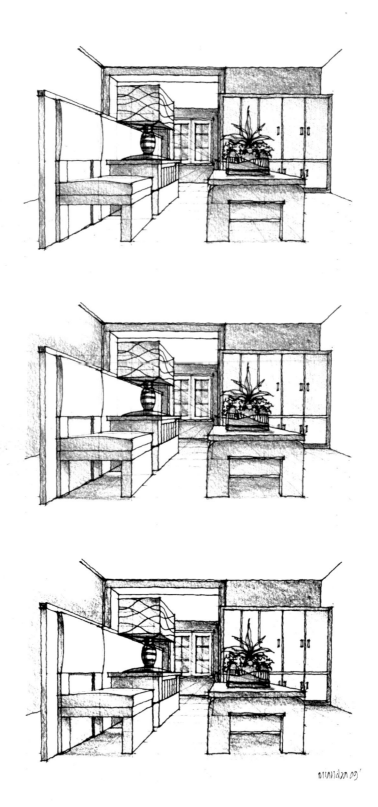

The final rendering shows how this soft touch adds to the
appeal and character of the entire sketch.

Pen Rendering

Use a 0.2 felt tip pen and apply the hatching technique to the objects.

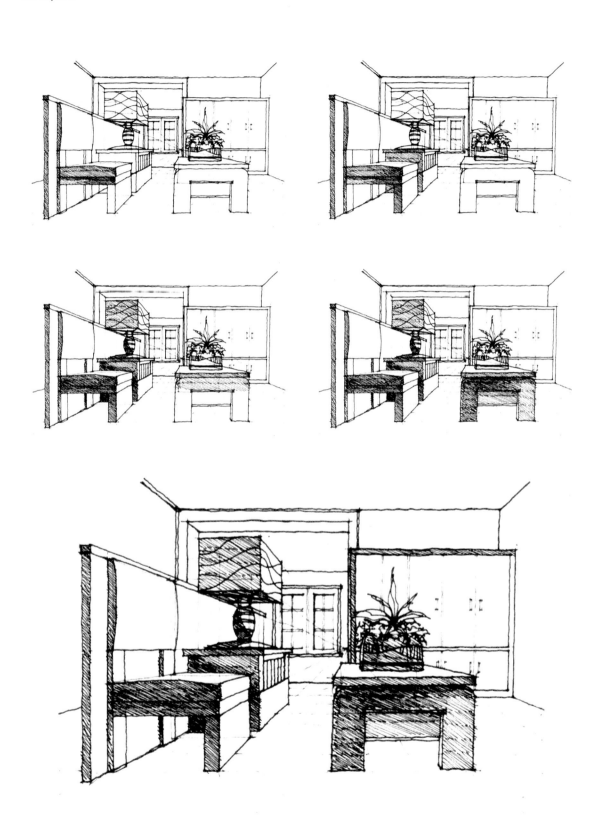

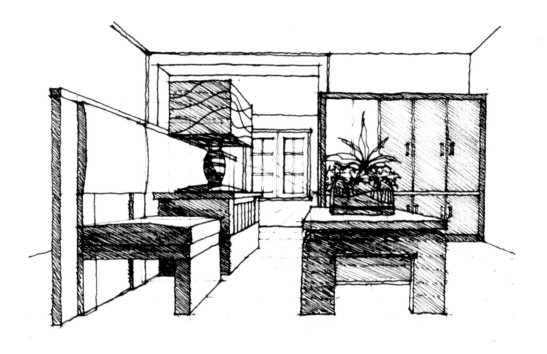

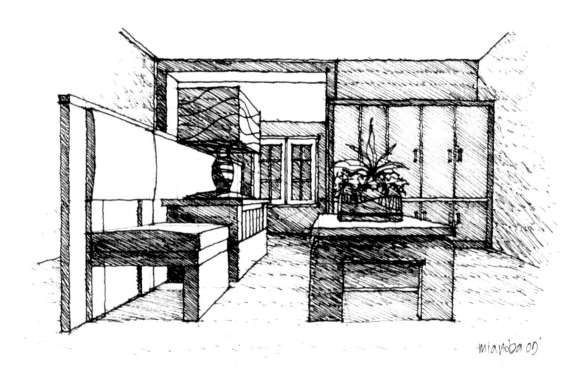

The outcome is a 'rough' look, similar to its rough hatched texture.

HOW TO DRAW A ROOM

Sometimes, an instrument such as a fountain pen with dark green ink can produce well-drawn lines and monotone (one colour rendering) effects for a sketch. I believe a good medium and proper drawing tools will produce quality sketches.

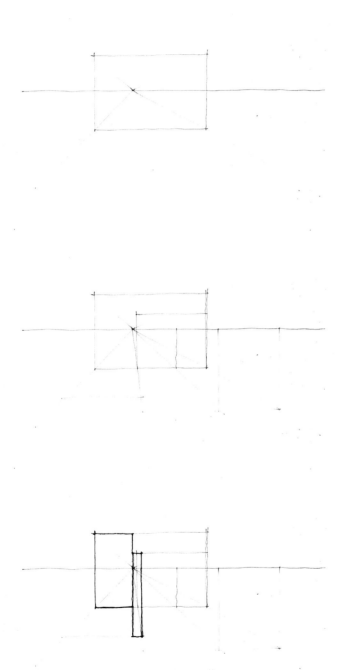

When using a fountain pen, take the opportunity to apply varied pressures to achieve different thickness of lines without having to change pens.

Observe how the imaginary box has been constructed. It uses a very thin line as a guide to draw objects inside it.

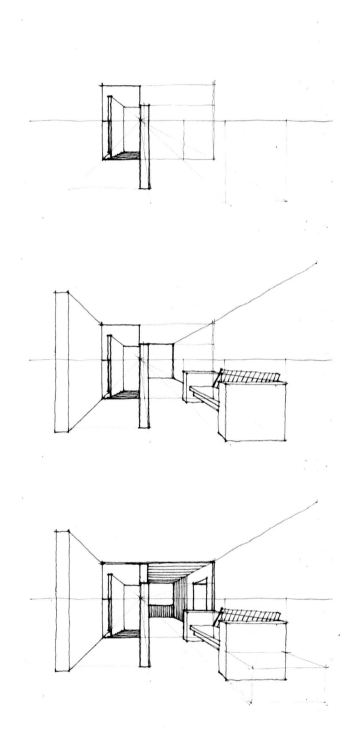

Notice that almost all of the imaginary boxes drawn are now invisible after the necessary lines have been emphasized through rendering.

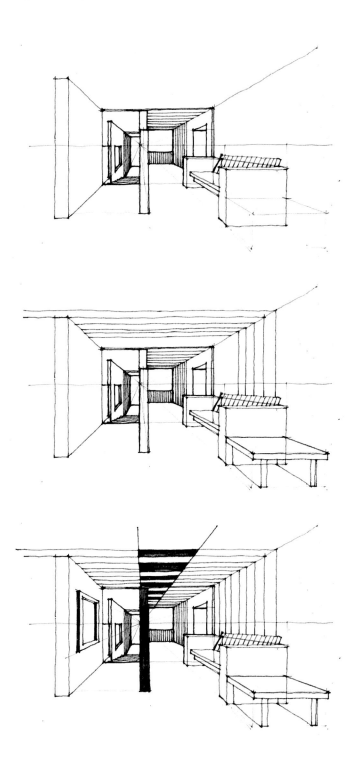

Tip 4: *Proper drawing mediums and tools provide added advantage in producing a good, quality sketch.*

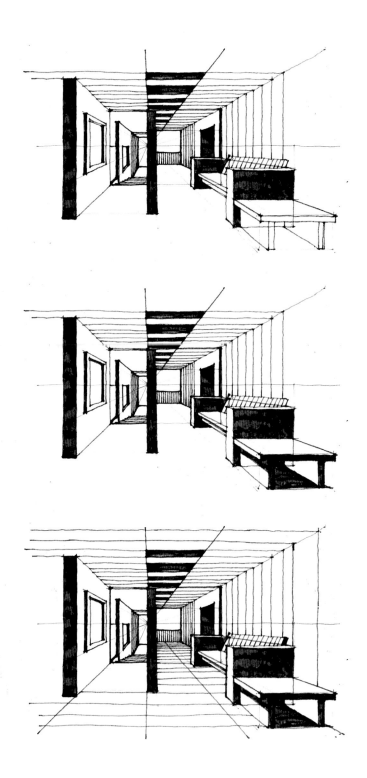

Using wet ink may produce a unique effect to the overall look and composition. Observe the step-by-step process that results in the final rendering.

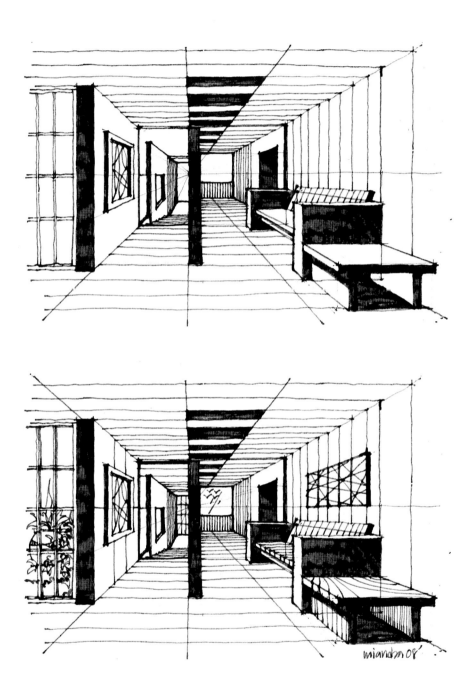

It is vital that apart from using the right medium and tools, we need to be creative as well when sketching.

HOW TO DRAW AN ARCHWAY

Everyone can draw well if they have ample practice and acquire
a deep understanding of the required knowledge and skills.

It is a common misconception that straights lines cannot be drawn without a ruler. However, these sketches illustrate that this is a myth.

Why do we need to draw lines without a ruler? Lines are normally sketched without one, especially when ideas come spontaneously, or when beautiful sceneries are encountered on-the-go. They should also be drawn with quality ink and of appropriate thickness.

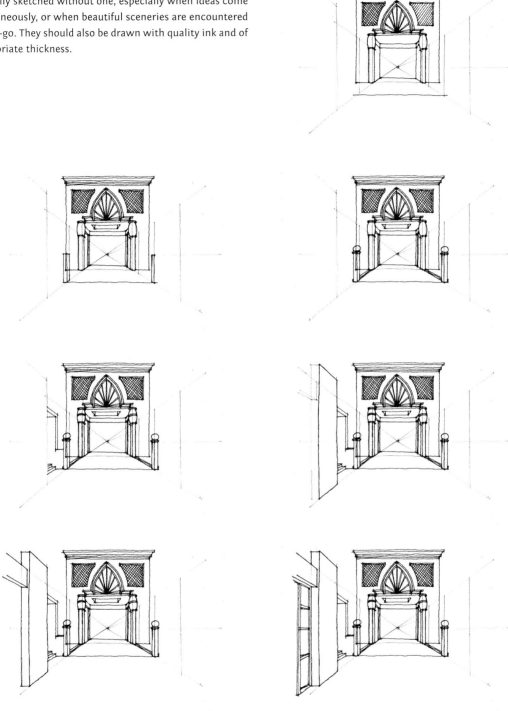

A good sketch is attributed to well-drawn lines. Observe the different thickness of lines in this example.

Quality lines can create depth and dimension, making a normal
sketch more lively and beautiful.

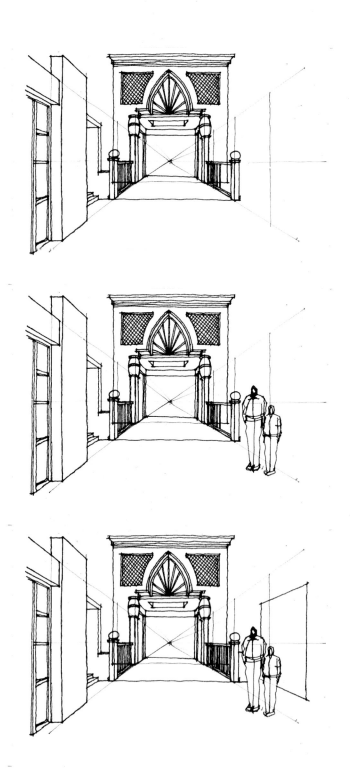

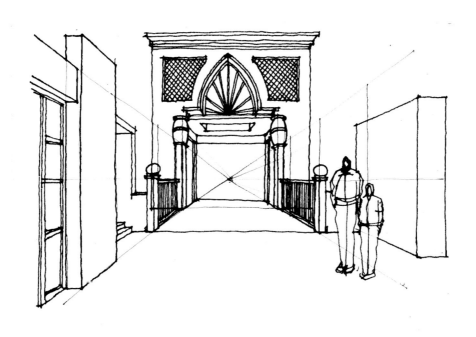

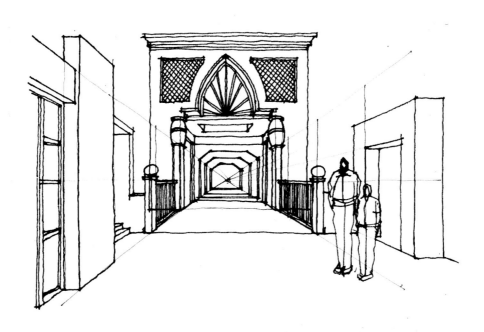

Detailing is also dependent on lines – each detail is drawn with lines of different thickness. Keeping this in mind, observe the floor tiling in comparison to the archway.

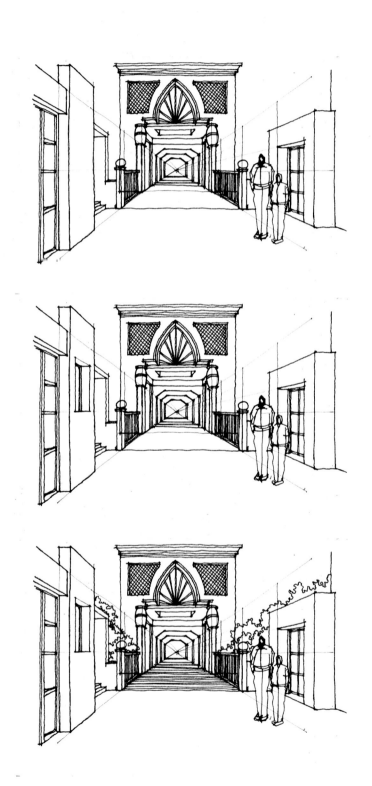

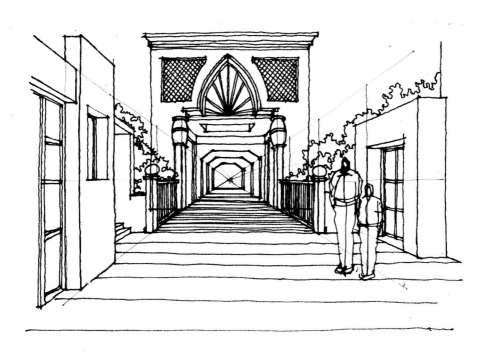

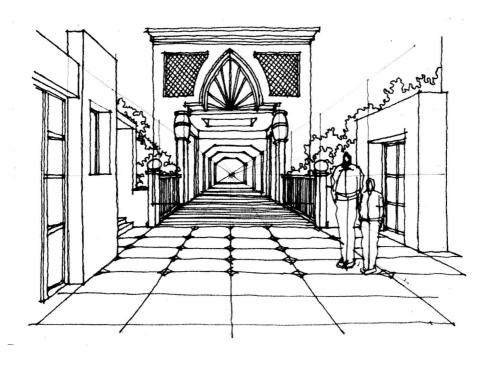

Notice that all the lines drawn in this composition comple-
ment each other.

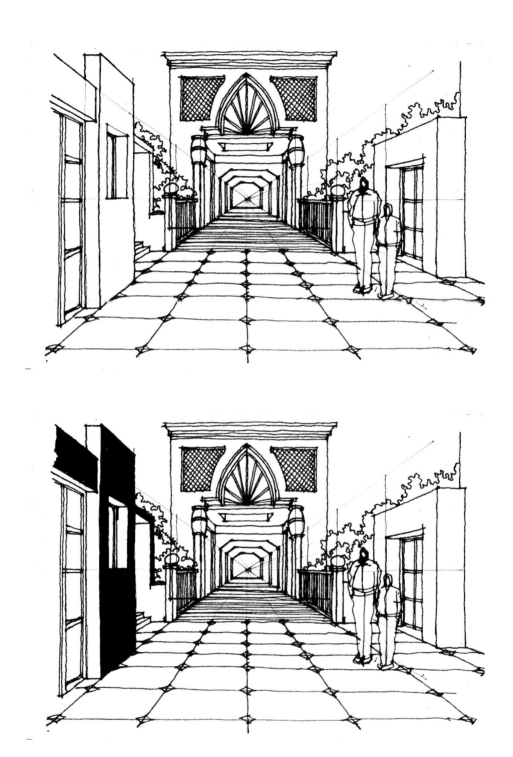

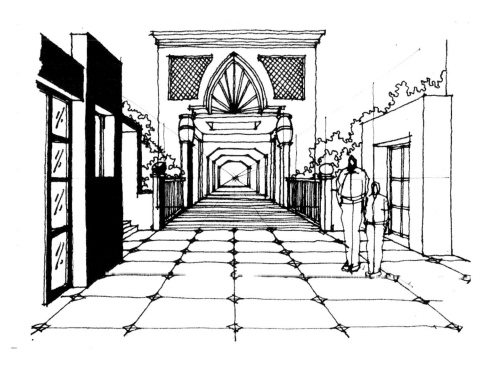

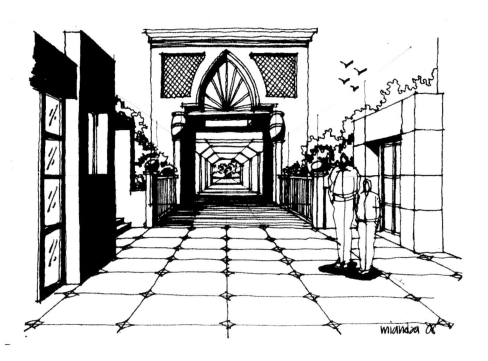

RIVER SCENERY

How do we improve our sketching skills? The answer is simple: Practice! Observe these steps and try sketching them on your own.

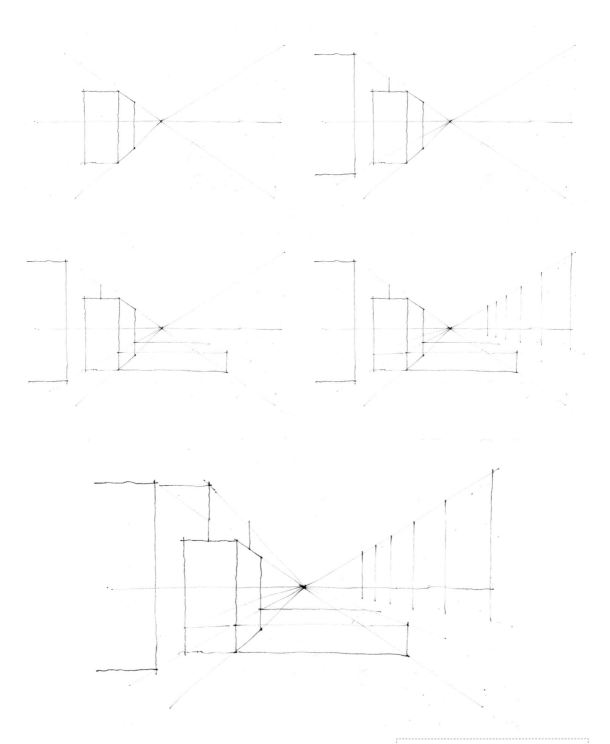

Tip 6: Practice! Practice! Practice!

As practice makes perfect, it will give you the confidence to tackle difficulties faced during sketching. The following composition illustrates the complexity of lines, challenging us to compose more interesting sketches.

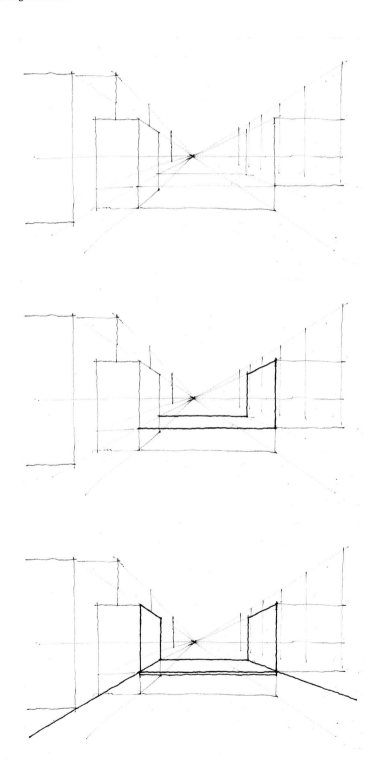

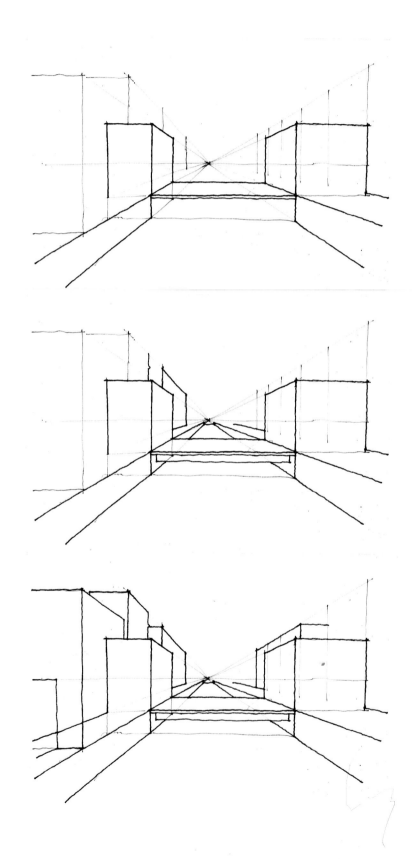

Always ensure that the major layout of the composition is
completed before detailing.

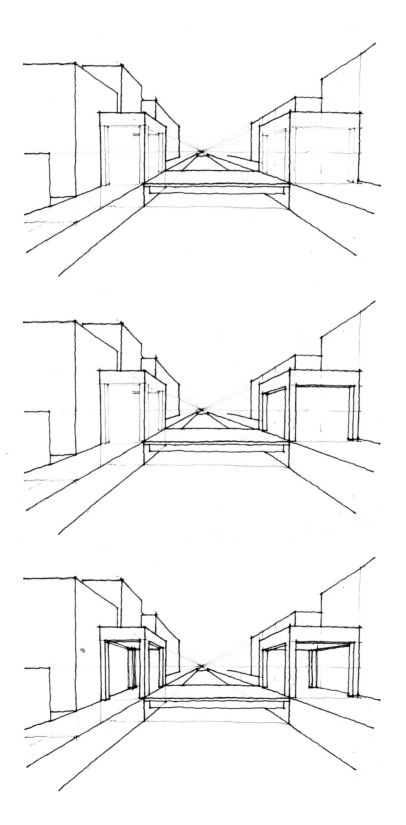

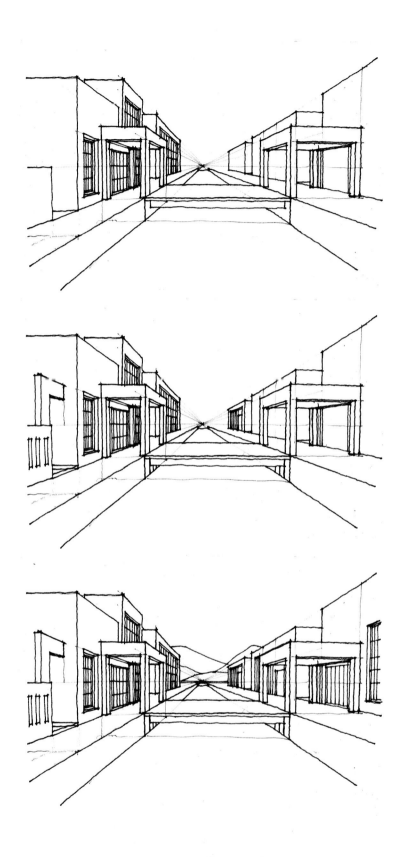

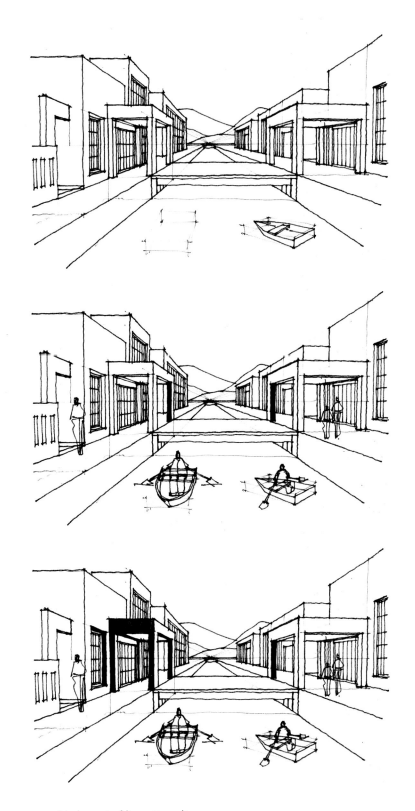

Practice also encourages good judgment of lines. Every line drawn can have very large positive or negative impacts on the entire composition.

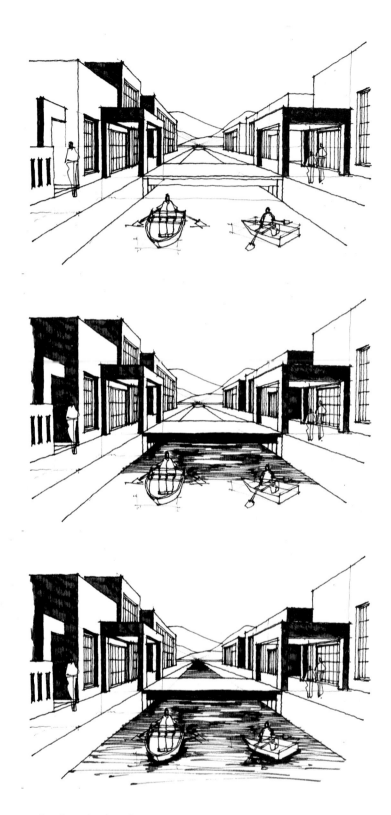

In this sketch, there are a few lines that have been correct-
ed. Over time, you will be able to easily identify such unde-
sirable lines.

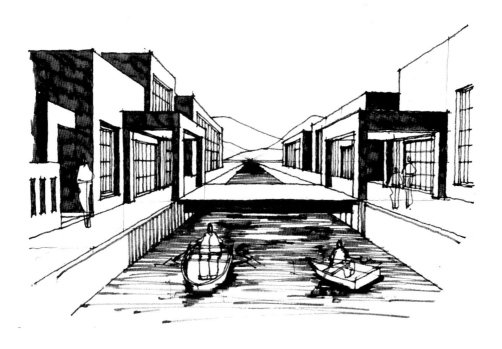

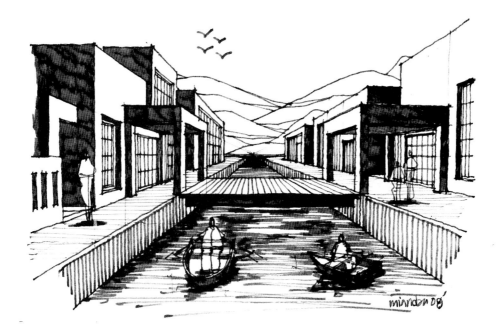

During rendering, always trust your eye to judge the starting
and ending points of your sketching and rendering process.

A STREET

The following step-by-step processes will demonstrate that the vanishing point plays a crucial role in creating a good composition.

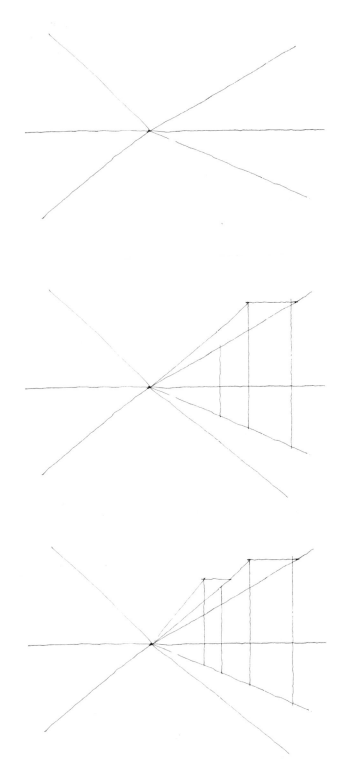

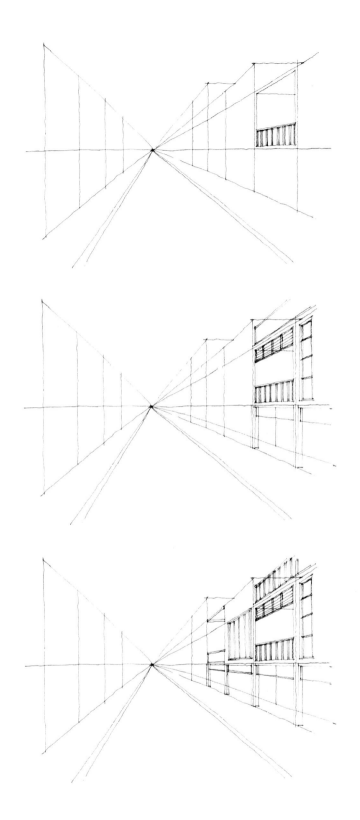

Observe the lines in this sketch where the vanishing point becomes the main reference point – it will always govern the setting of the view within the composition.

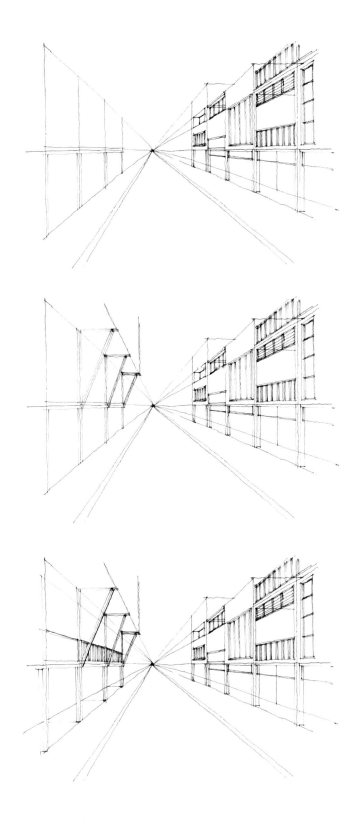

Understanding the vanishing point and how it functions within the sketch always helps in creating proportionate compositions that are to scale. Observe how the vanishing point relates to the objects here.

Tip 7: Practice makes perfect.

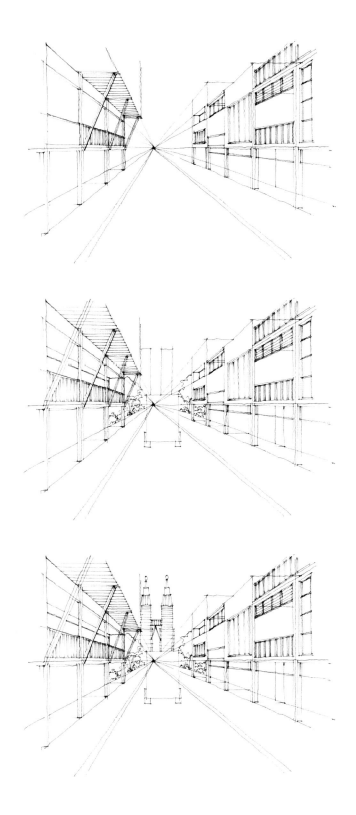

In the final stages of a sketch, the location of the vanishing point is seldom identifiable. It is often hidden by objects drawn in front of it. Observe how this is so here.

This sketch shows that the vanishing point is hidden by a truck drawn on the road that is moving towards it. Upon rendering, it will disappear almost entirely.

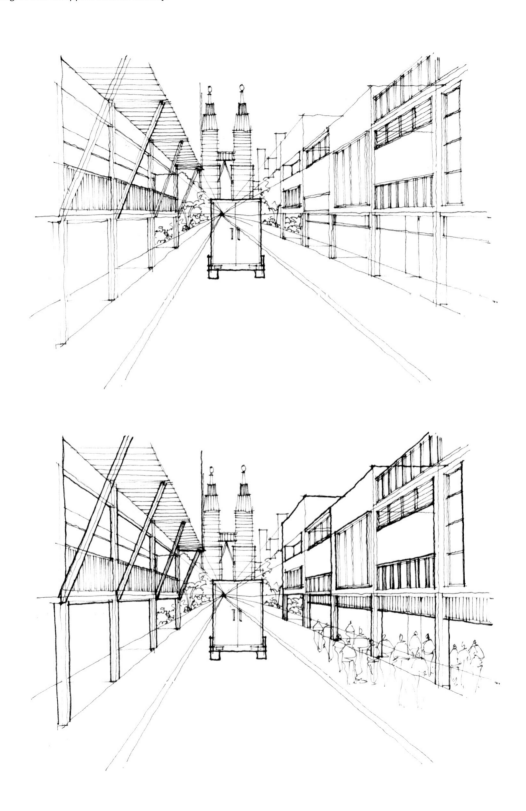

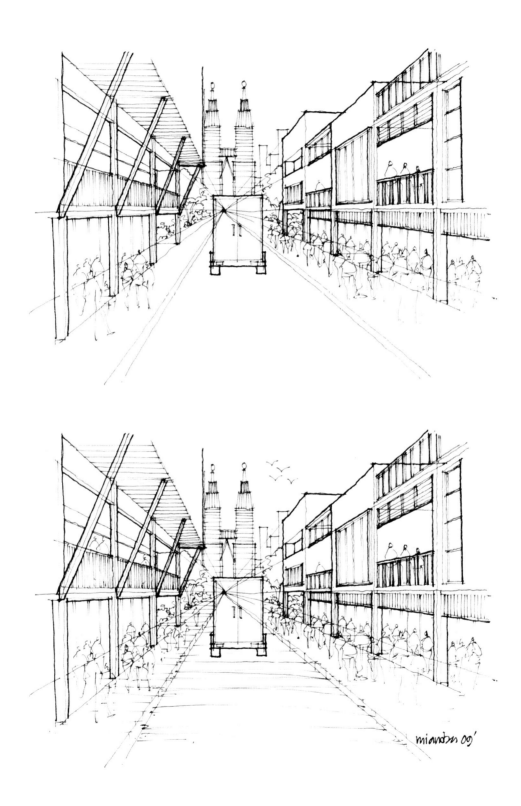

Art Marker Rendering

Where to start? This is a common question asked when one intends to apply colours onto a sketch. There is no definite answer but artists often start colouring the background first.

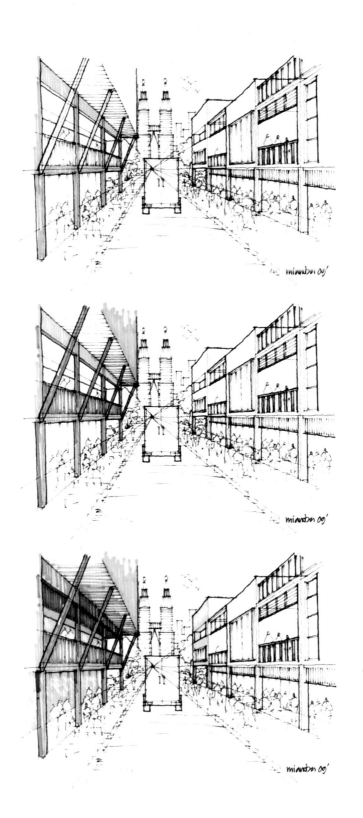

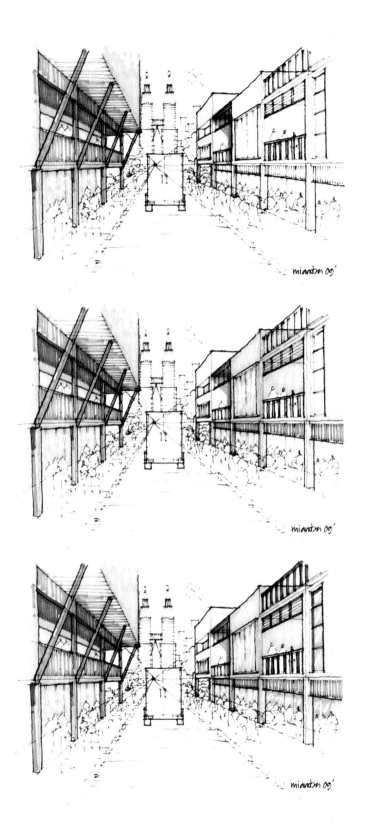

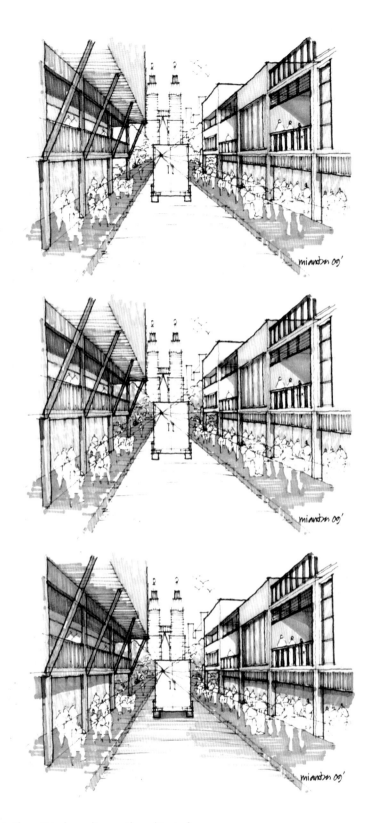

Ultimately, it is up to the artist, depending on the subject of
the sketch dealt with. Here, colours are applied to the left
façade before moving on to the right-hand side.

Subsequent colouring is entirely up to you.

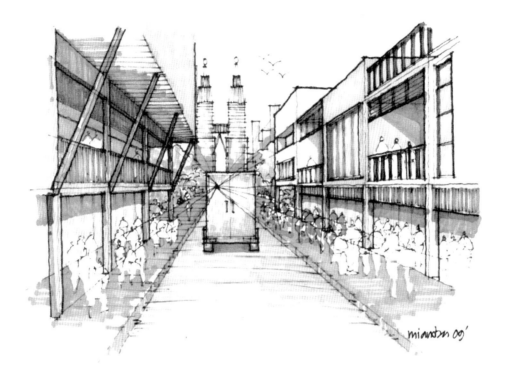

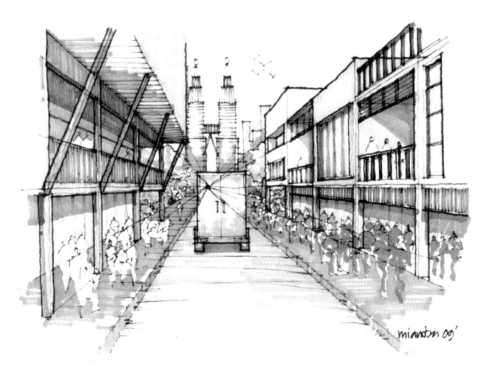

It is best to add colours according to the ambience you wish
to create.

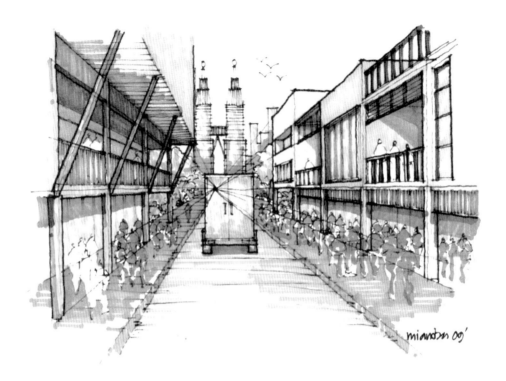

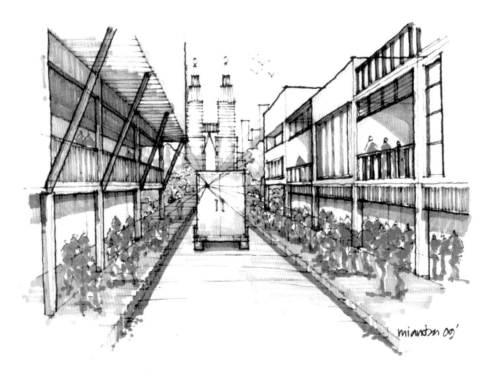

Pen Rendering

Pen rendering is a favourite technique among artists and designers to avoid difficult choices when deciding on a colour scheme. It is important to know how to apply shades and shadows appropriately during pen rendering.

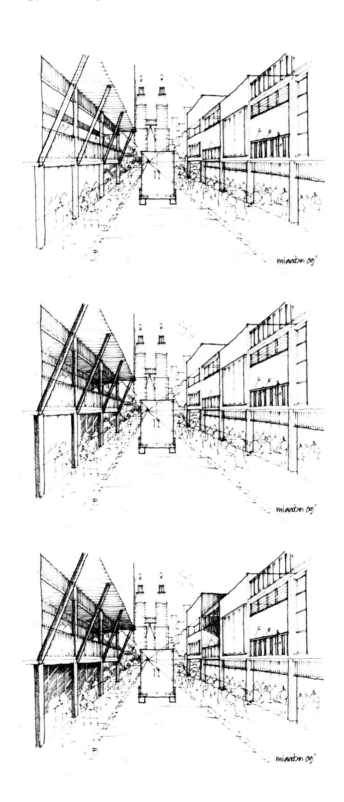

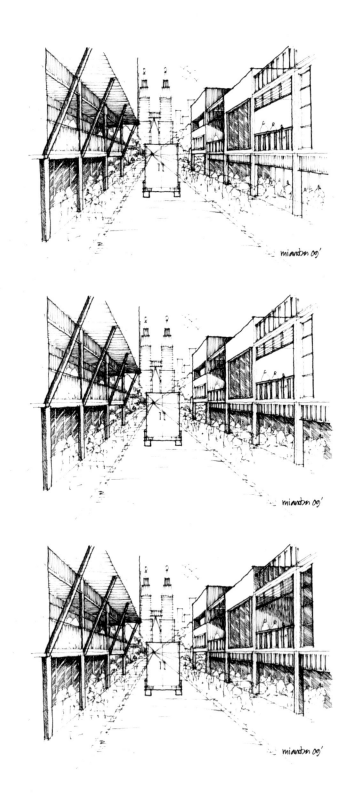

We need to be creative in defining areas that require the application of shades and shadows – it will determine our proficiency in handling pen rendering. This is also a subjective process where, skills, experience and knowledge are imperative.

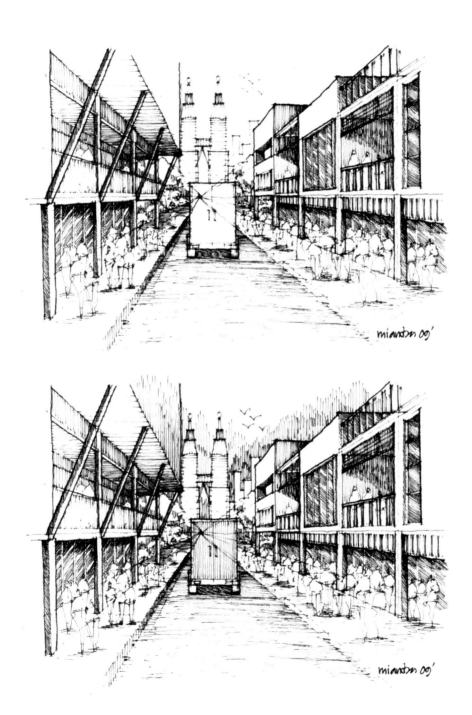

Do not forget to stop during the rendering process as over-rendering may lead to unsatisfactory results.

COMPLEX URBANITY

Do you know that wonders can be created from a simple one point perspective? This sketch demonstrates how we can construct a complex urban area just as easily.

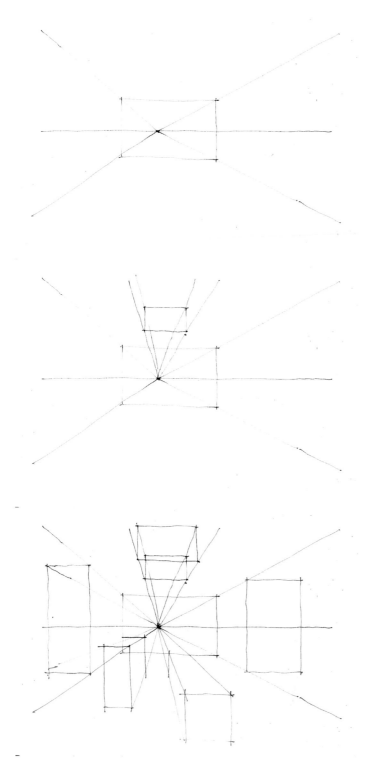

Tip 8: Draw both straight and curvy lines with confidence.

By paying attention to the concept of the imaginary box and the basics of perspective, anyone can draw a complex setting. Observe the steps in transforming these boxes into buildings.

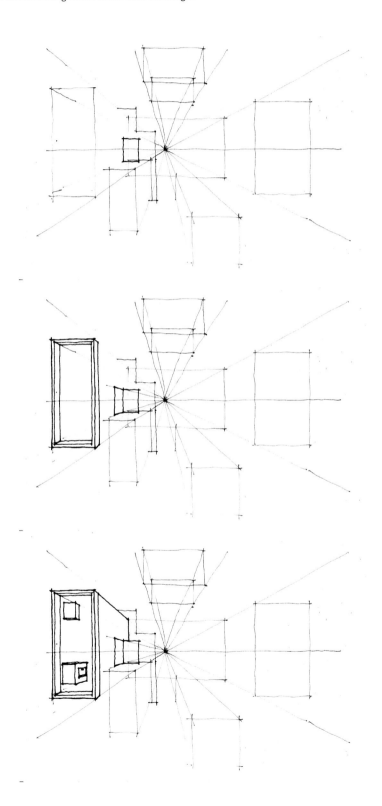

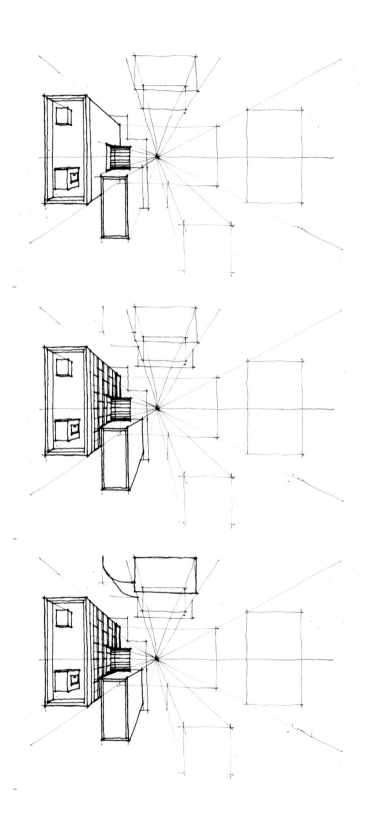

This sketch also illustrates the potential of using imaginary
boxes to justify street layouts.

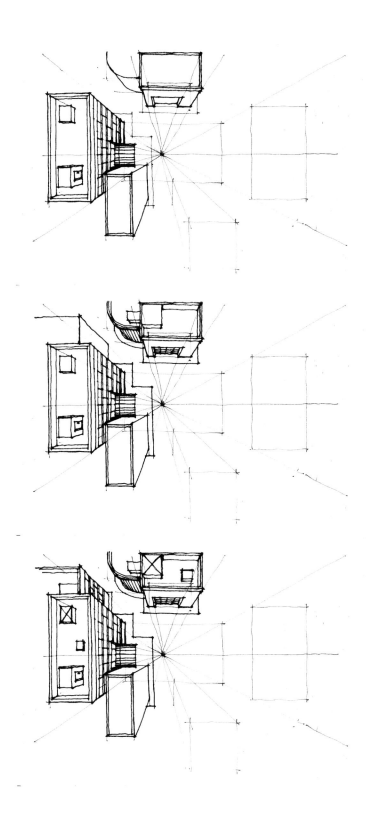

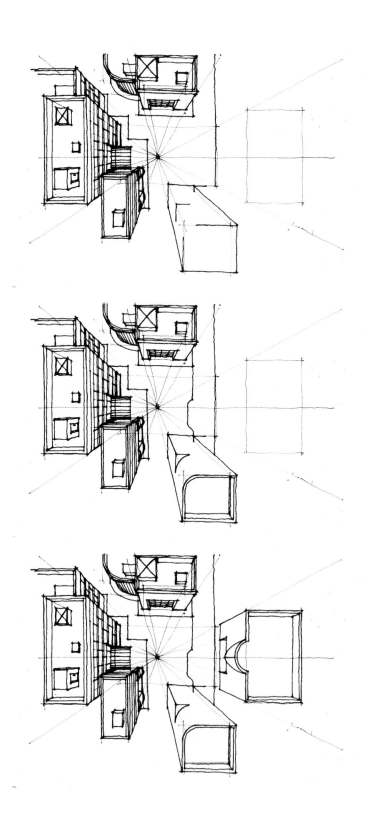

Detailing of the buildings and streets are done after the major layout of the composition is finalized. Observe this step-by-step and look at all the details on the buildings and even on the streets.

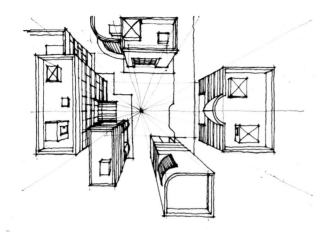

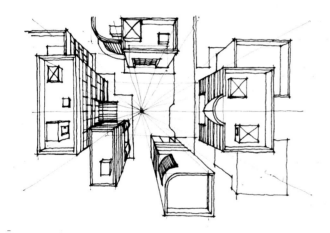

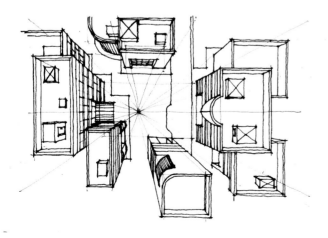

Do ensure that all detailing made should adhere to the one point perspective rule for a scaled and sound composition.

This detailing process is similar to the sketch of a simple
room. The only difference is the envelope of imaginary boxes
created in this particular sketch.

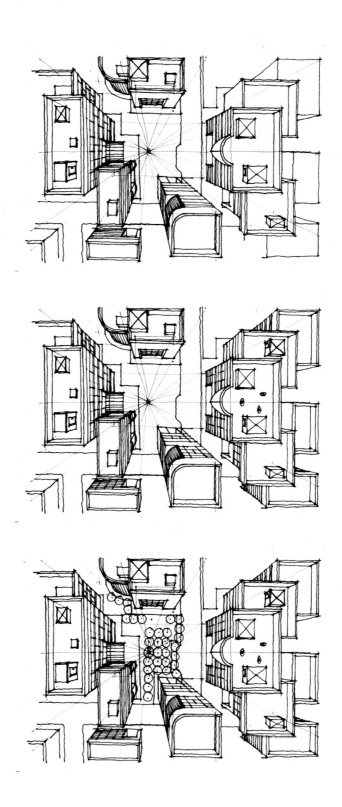

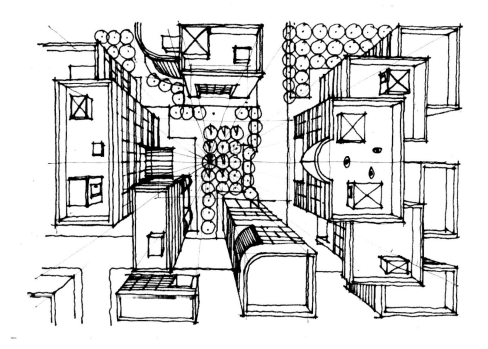

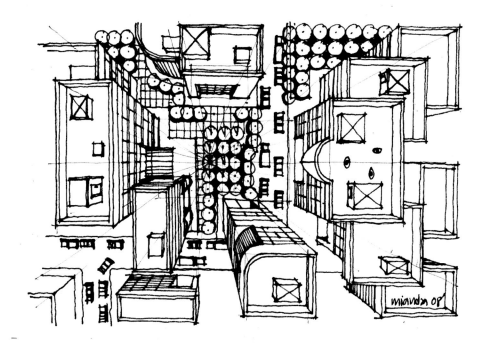

Noting the changes in these two sketches, you will see that
simple rendering preserves nice detailing.

A SIMPLE ROOM

As the horizon line determines your eye level, it is the first perspective component that should be drawn upon when setting the view in a sketch. In addition, the eye level is important in determining the level of a room as well, or any other setting, as shown here.

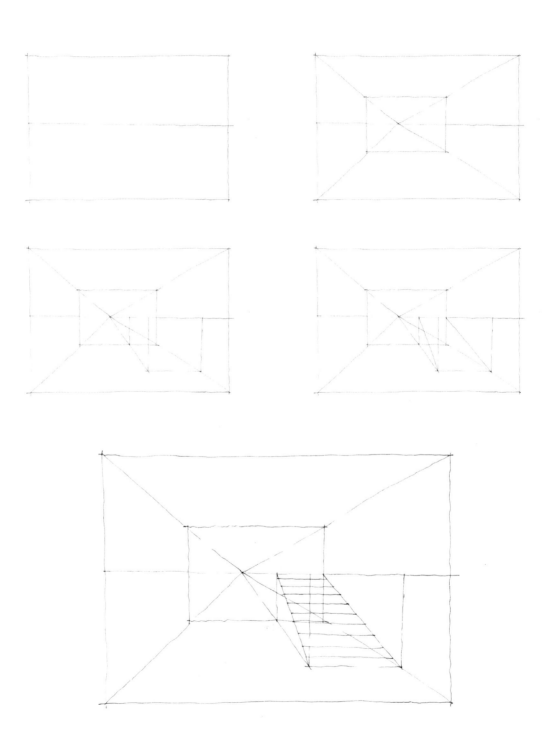

By learning to draw split-level rooms where they are connected by steps or a staircase, your skills in handling two levels within a single perspective will be challenged.

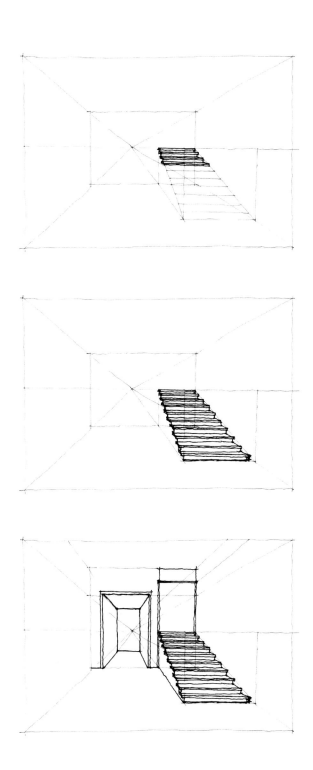

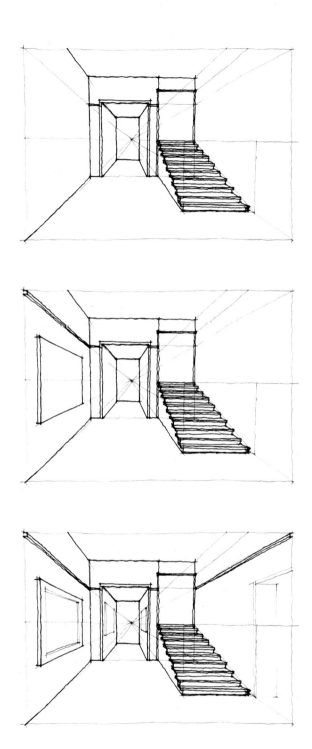

While creating different levels in a room seems simple, positioning the steps or the staircase may be tricky. Look at this sketch and how the imaginary box has been used to create the steps that link the two levels – it simplifies the process of splitting two different planes.

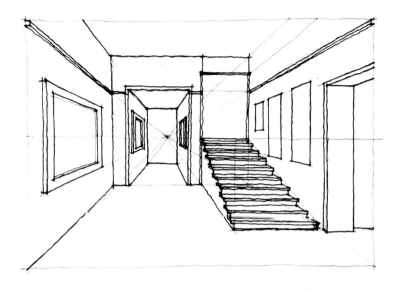

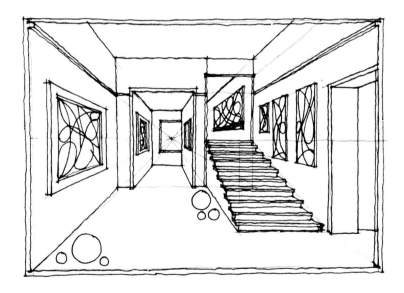

This is the final sketch after using the imaginary box to aid in drawing the steps, using the horizon line as a reference.

Art Marker Rendering

What colours should one choose for various walls? Before adding colours, the ambience intended for the setting should be identified first. This is because the ambience of a room can be affected greatly if a warm or cool colour is chosen for its walls.

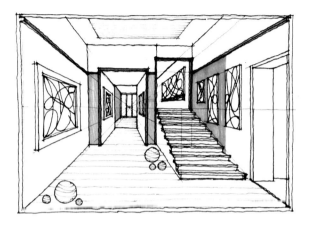

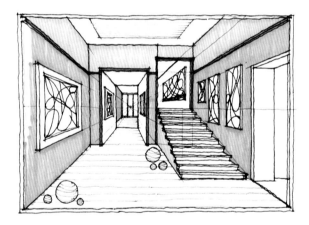

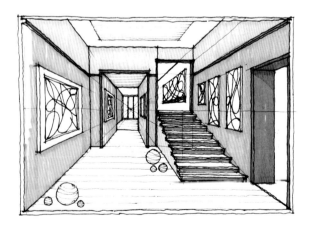

The technique in choosing colours and applying them requires time and practice.

It is a skill that is hard to acquire but feel free to explore what others have done through magazines, books, and the internet. Learn to observe and be aware of your surroundings and the spaces that you encounter daily.

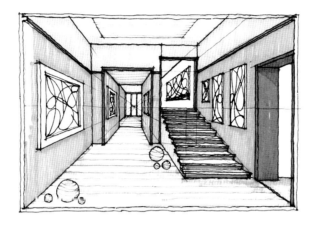

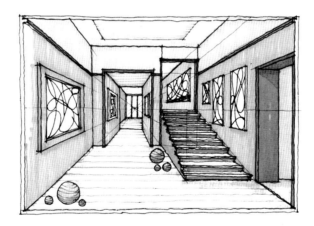

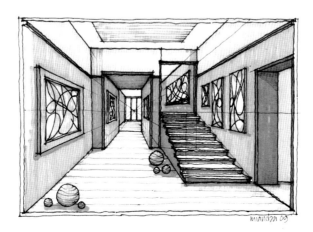

STEPS

It is difficult to be sure which lines are the best for sketching as they vary accordingly from individual to individual. Often, the best thing to do is to trust your own judgment.

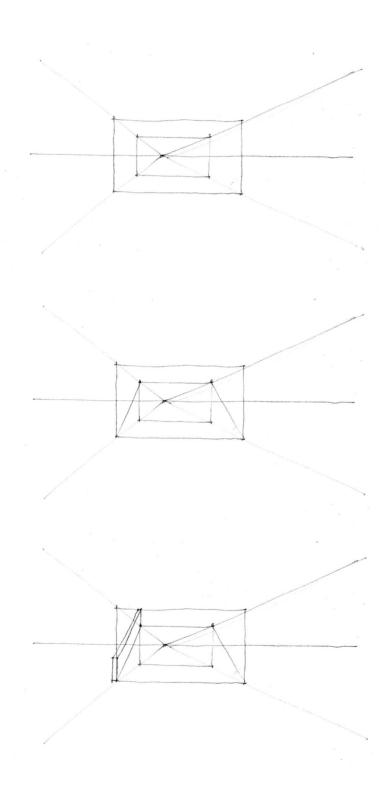

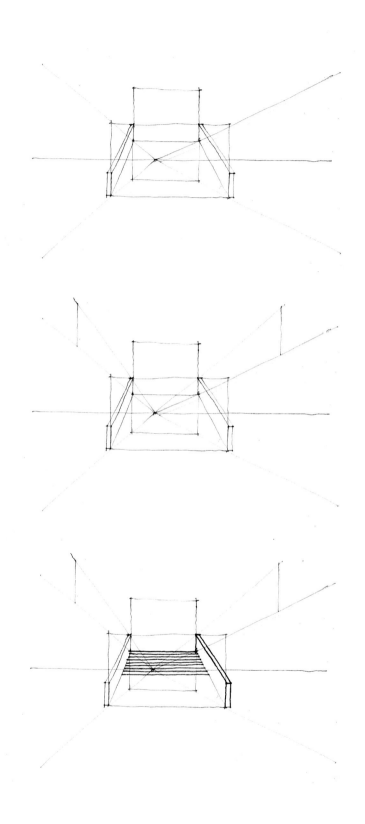

Lines are also dependent on the artist's unique style and the rules within a particular sketching technique.

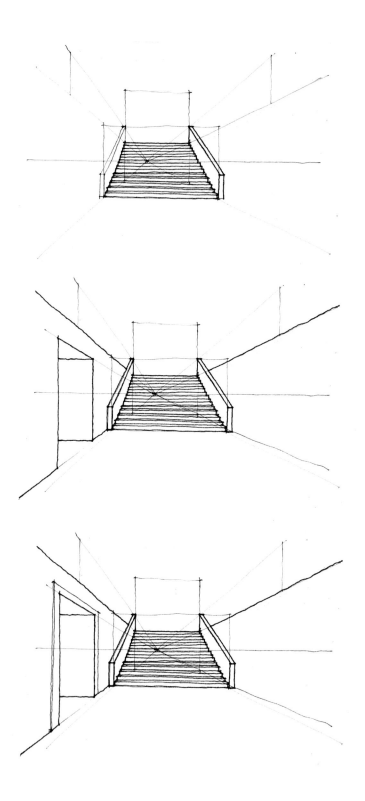

It is only with confidence that we can produce good lines that fit any particular setting. Remember that confidence comes naturally with a lot of practice.

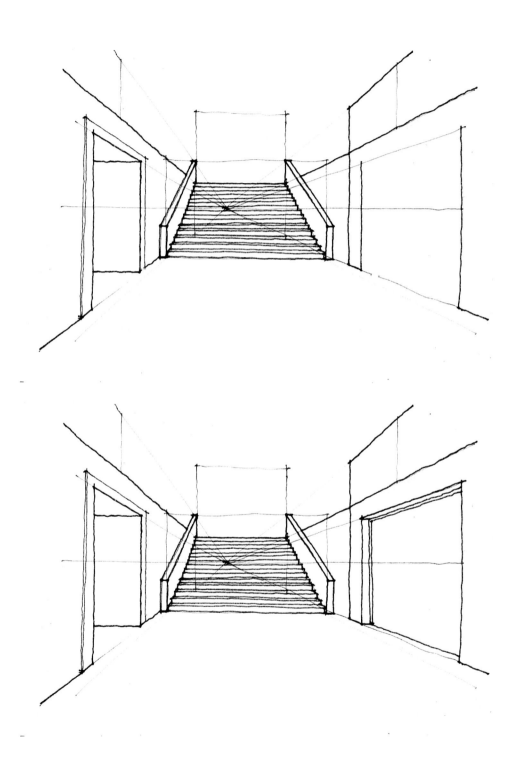

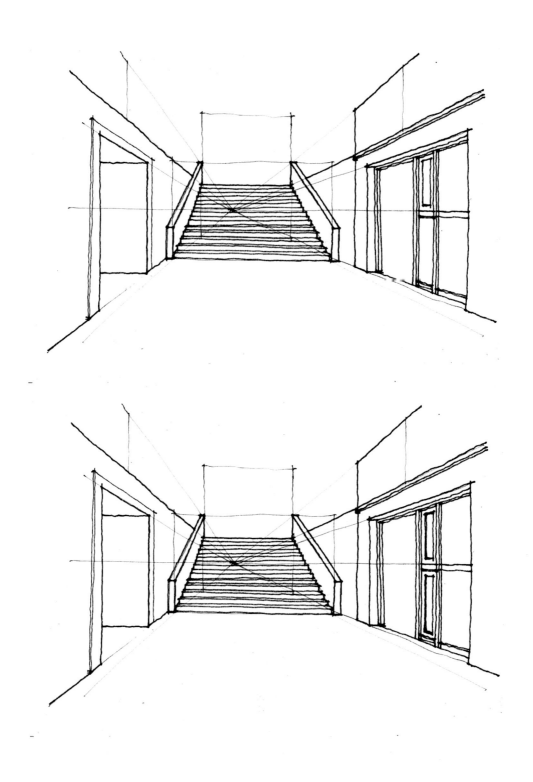

Observe how the lines differ in thickness and in stroke. Each line has its own identity and character which contributes to the entire mood of the composition.

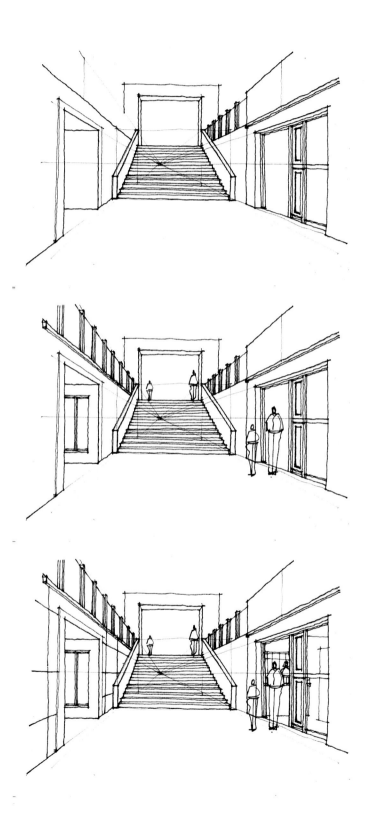

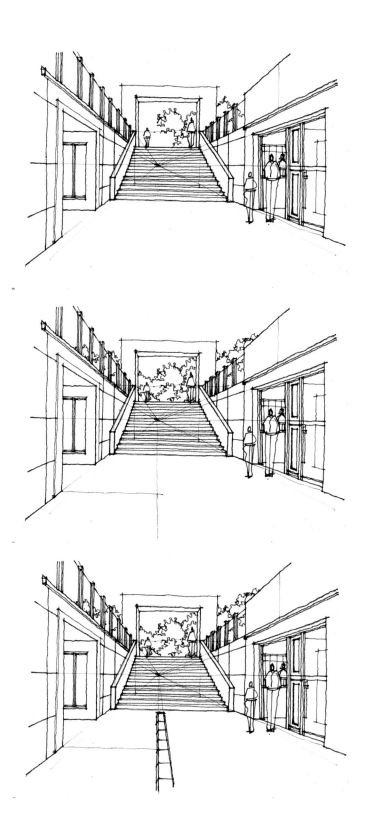

Rendering techniques also require well-drawn lines to produce
good hatching results.

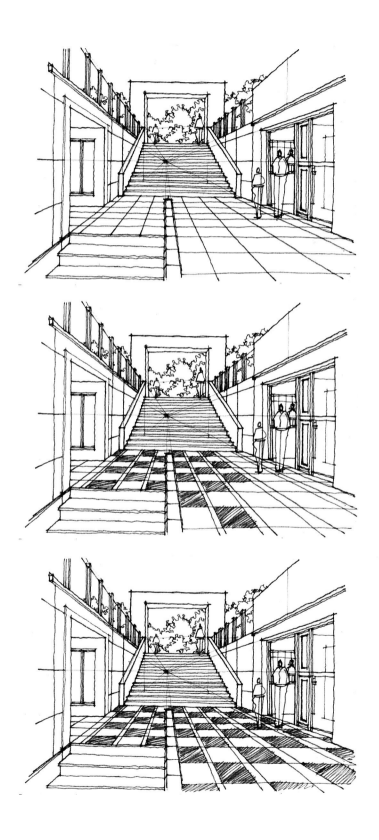

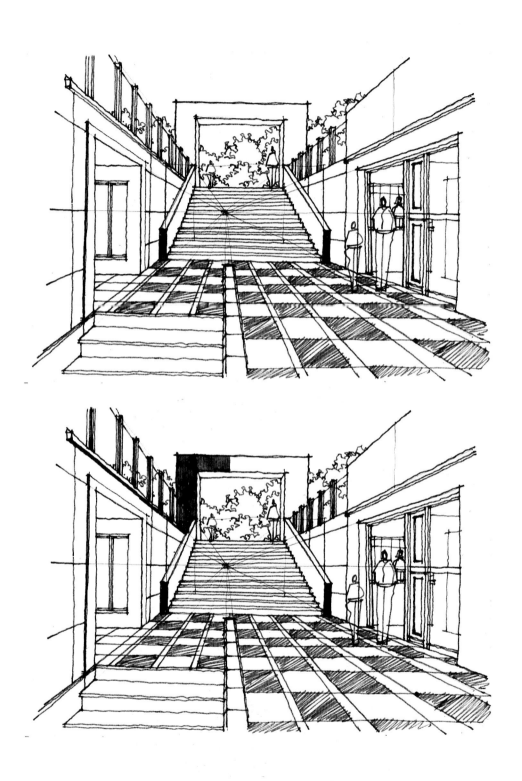

Besides producing conducive settings for hatching, good lines
contribute to accurate shading and shadowing as well.

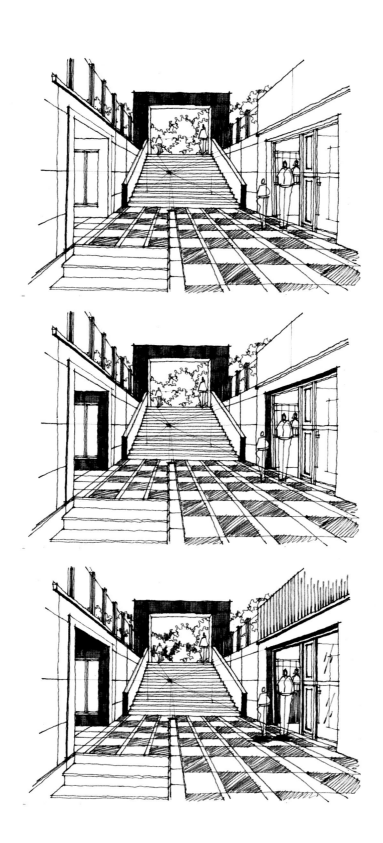

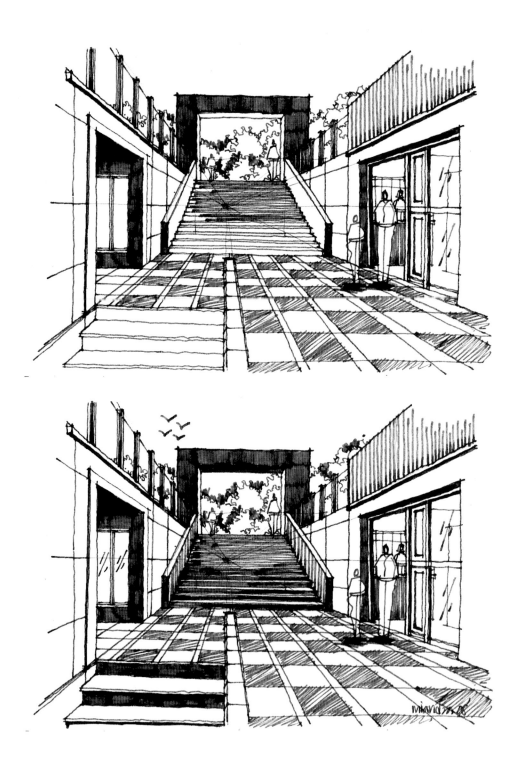

A COMPLEX ROOM

When one has an excellent understanding of using the imaginary box and the one point perspective approach, he or she will be ready to deal with any complex compositions.

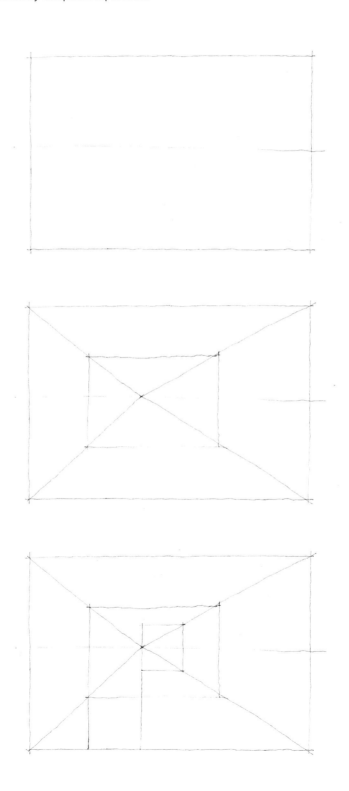

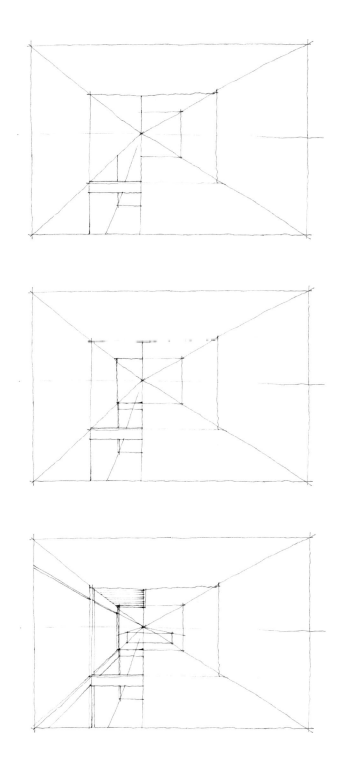

Complex compositions require more attention paid to lines as many of them are needed to construct a sketch. A single linear error can have a big impact on the overall look of the final piece.

Tip 11: *Good shading and shadowing results in good sketches.*

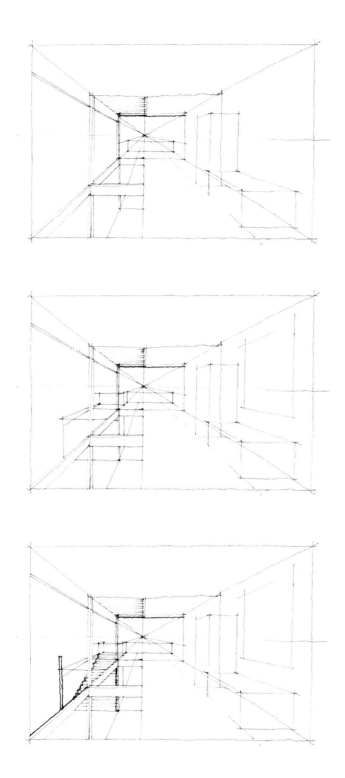

Observe how some of the lines were drawn in the wrong direction with reference to the vanishing point, especially at the staircase. During a situation like this, one must correct it to avoid compromising the accuracy of the sketch.

Mistakes are unavoidable but it is advisable to break the
habit of repeating them.

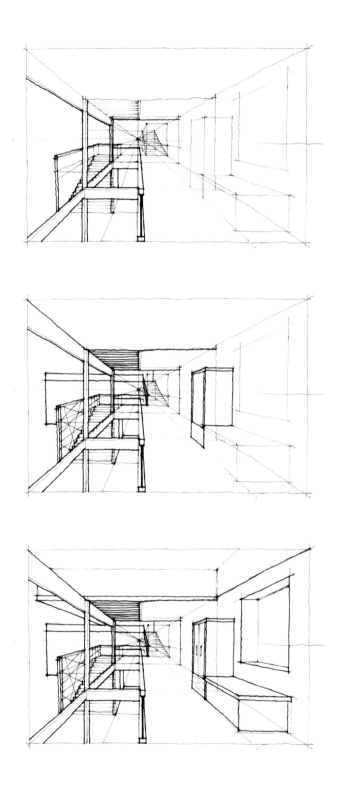

Linear errors are common but those regarding the objects'
proportions need to be avoided as they play an even bigger
role in affecting the final piece.

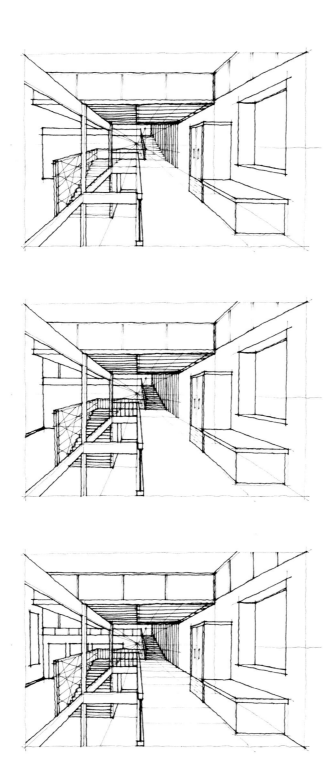

How is good scale and proportion achieved? The trick is to se-
lect one object as a reference for other objects. In doing so, the
proportion of all objects will be holistically proportionate.

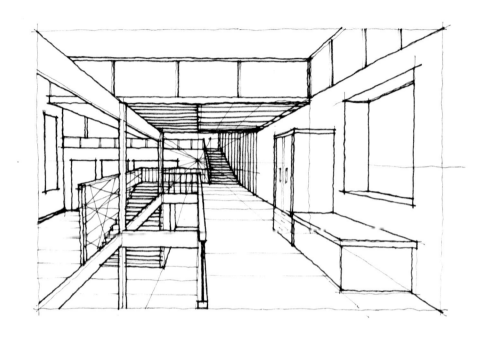

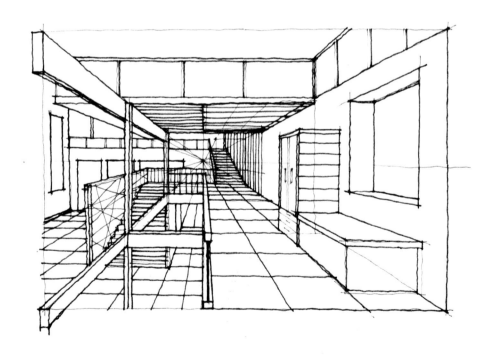

Art Marker Rendering

How should an art marker be used? Beginners may find it difficult to control the marker's ink flow depending on the sensitivity of the medium used.

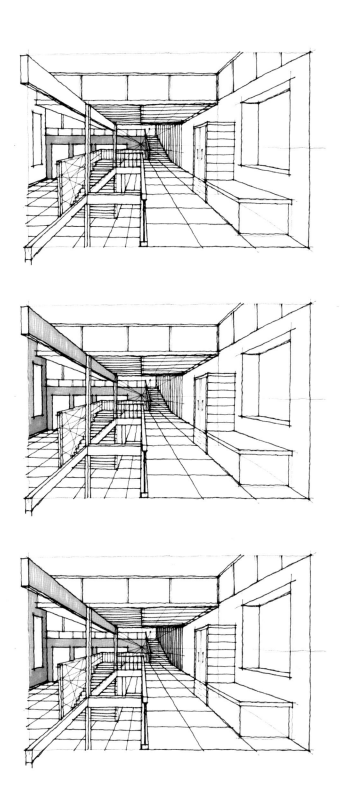

For example, rice paper is more sensitive in comparison to water colour paper, which will affect how you apply ink.

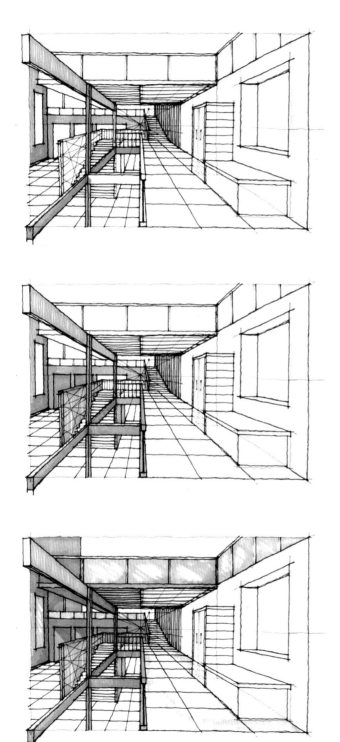

A suitable medium is a must for art marker colouring to stand out brilliantly.

Observe the process of applying colours to the wall, floor
and glass overhead beams here.

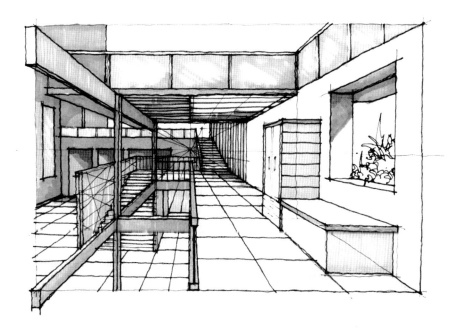

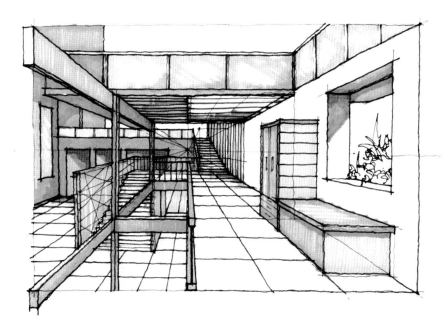

Look at the seating area. The colour grey was used to pro-
duce shades and shadows which highlight the effect of the
light source and enhances the overall ambience.

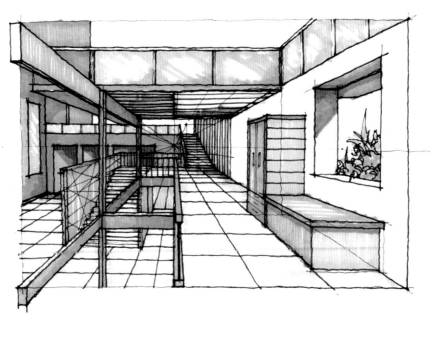

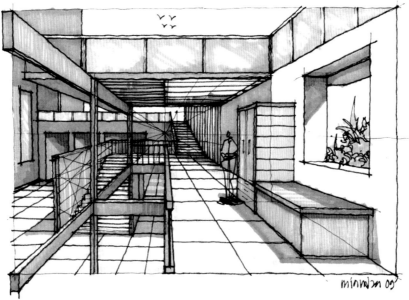

The colour grey plays a very important role in emphasising
the areas that will have an influential impact on the overall
composition. However, we can also use other colours de-
pending on the mood and chosen colour scheme.

Pencil Rendering

What kinds of pencil grades are suitable for pencil rendering? It is best to select them based on the effects required. Use 4B to 8B grades for a soft effect, and B to 3B grades for harder effects (suitable for the hatching technique).

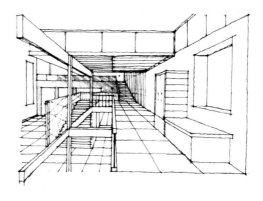

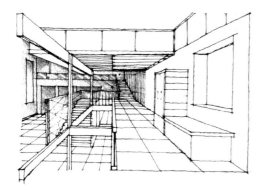

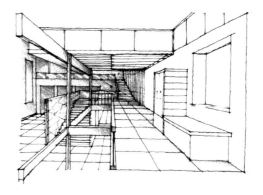

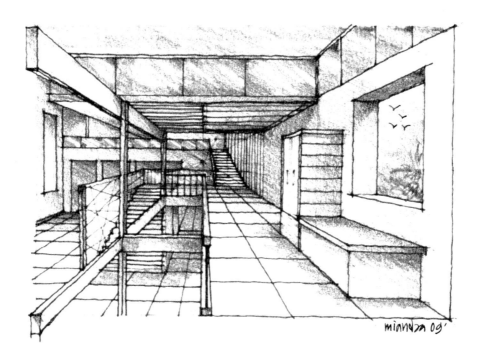

This is the completed sketch after using a 4B grade pencil for rendering.

CHAPTER 3

THE IMAGINARY BOX IN
TWO POINT PERSPECTIVE

In this setting, the imaginary box is created using two van-
ishing points as its references to form compositions. Even
though beginners new to this approach may face initial dif-
ficulties, these problems can be solved through practice and
by correctly identifying the two vanishing points.

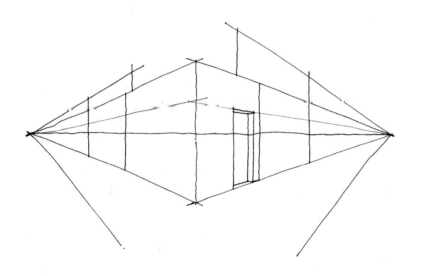

*These are some examples of
how to form the imaginary
box using the two point
perspective.*

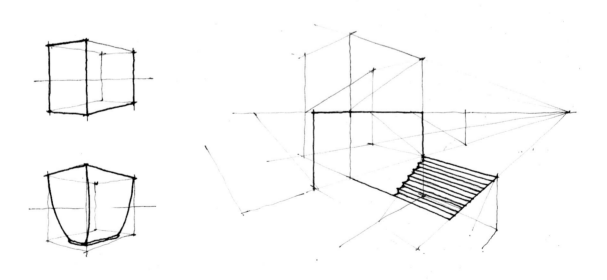

HOW TO DRAW AN OBJECT (A)

This exercise is good for the beginners. Choose any simple object that you like and draw it using the imaginary box.

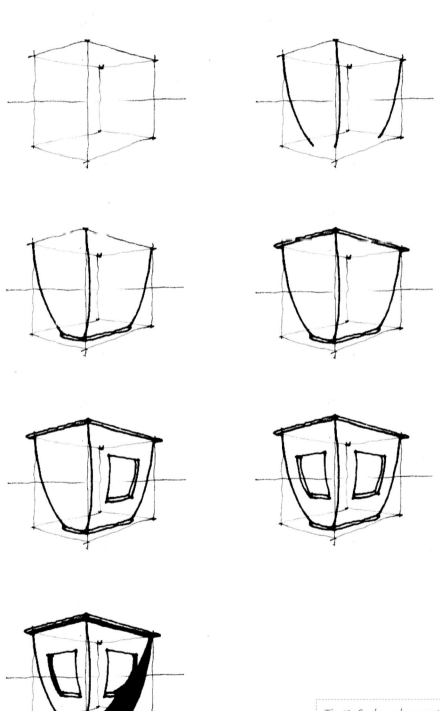

Tip 12: Scale and proportion are very important in the sketching process.

HOW TO DRAW AN OBJECT (B)

Always draw the imaginary box based on the object's size and shape.

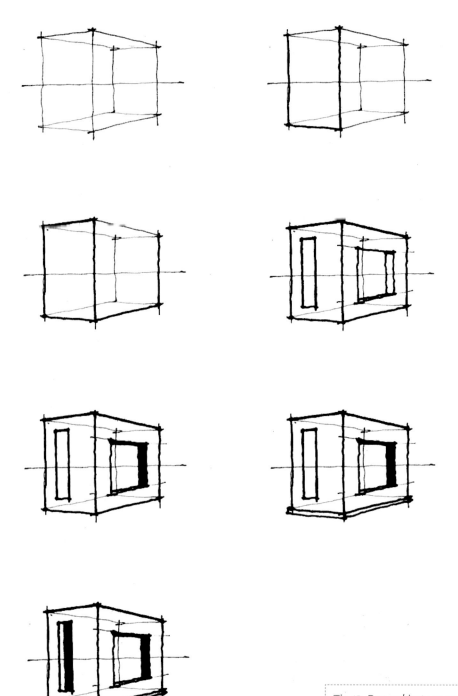

Tip 13: Draw objects or sceneries from imagination to improve your sketching.

HOW TO DRAW AN OBJECT (C)

Observe the process in creating the legs of a chair here.

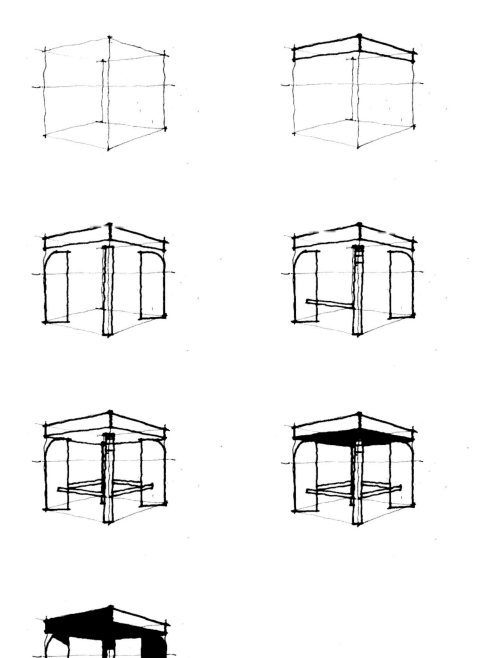

Tip 14: Start sketching simple objects first before moving on to more complex ones.

HOW TO DRAW AN OBJECT (D)

Look at how this lamp shade was drawn by visualising the imaginary box.

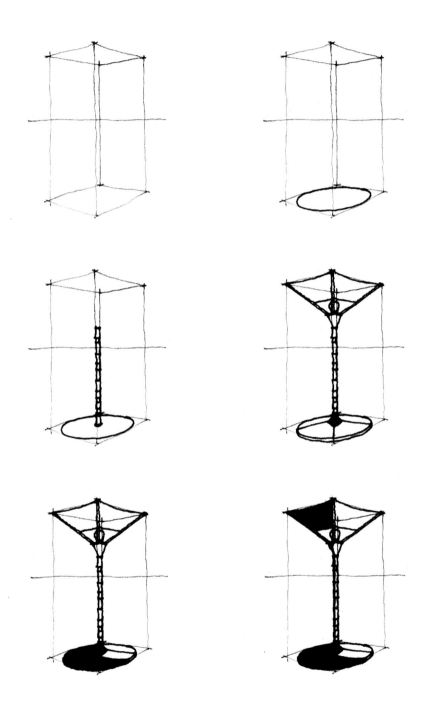

Tip 15: A two point perspective has two vanishing points.

HOW TO DRAW AN OBJECT (E)

Study how these lines were drawn to create the refrigerator.

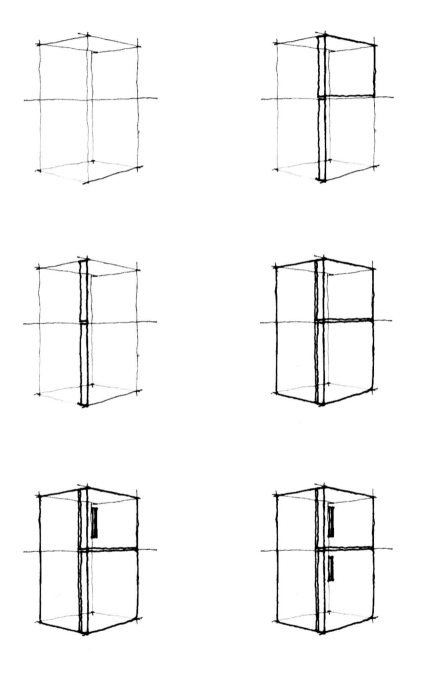

Tip 16: *The imaginary box can assist us in getting the right scale and proportion in a composition.*

HOW TO DRAW AN OBJECT (F)

Notice how the smaller objects on the shelves were drawn
using smaller imaginary boxes.

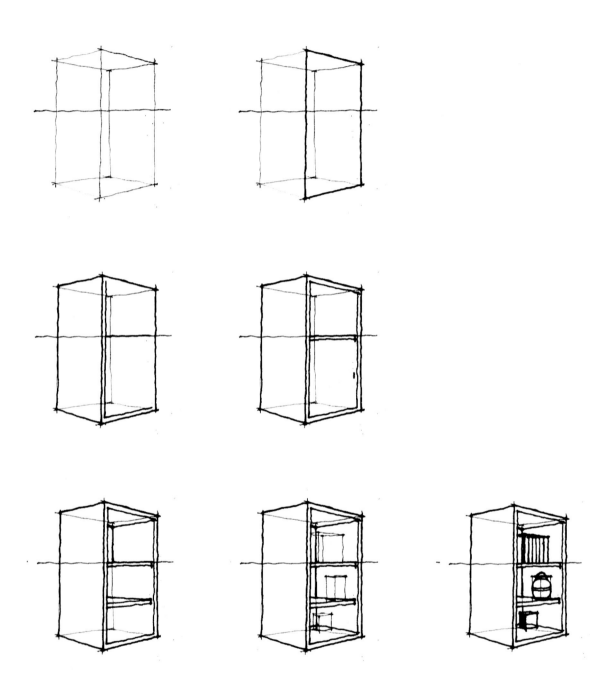

Tip 17: *Quality shading
and shadowing produces
quality sketches.*

HOW TO DRAW A ROOM

Before sketching, always ensure that the horizon line is in position. This is important in determining your eye level.

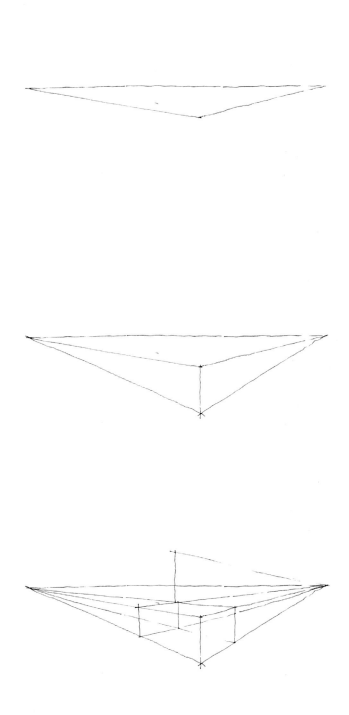

Tip 18: The horizon line helps us to determine the eye level.

Imaginary boxes that we draw must refer to the horizon
line. This is important in determining the outlook of all the
objects' surfaces.

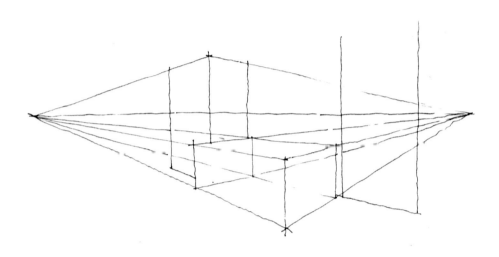

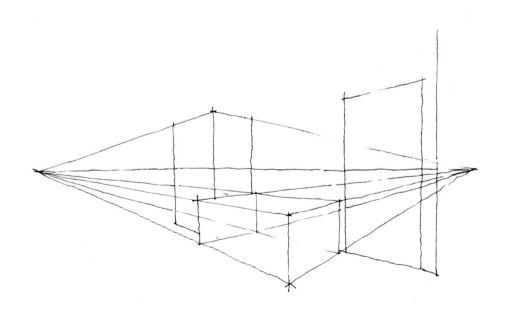

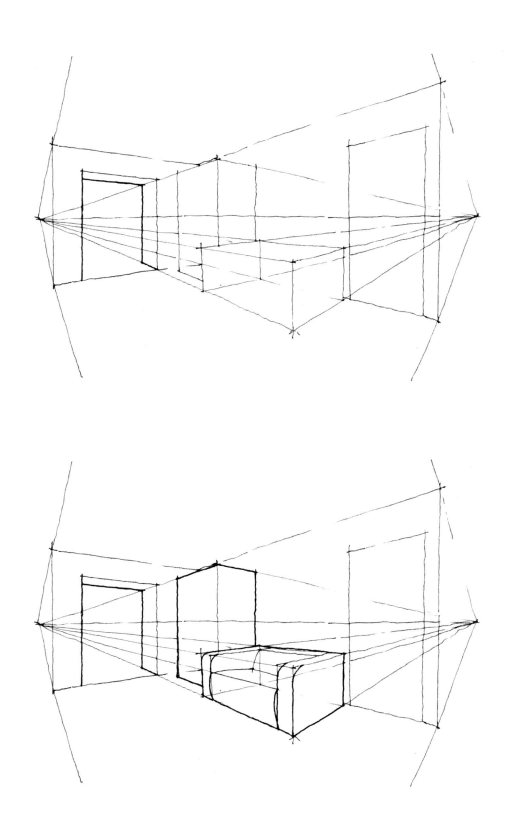

Observe the objects' surfaces in relation to the position of
the horizon line.

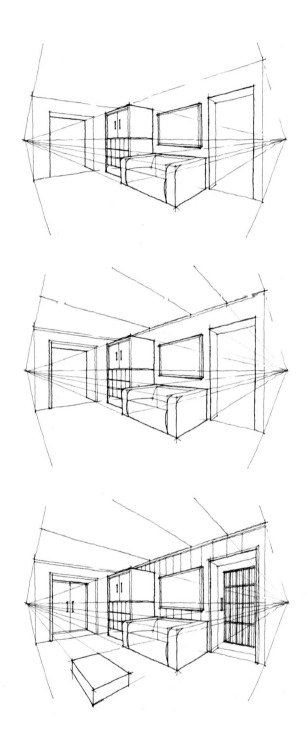

Looking at the objects' surfaces drawn below the horizon
line, especially the sofa, we can clearly make out its top sur-
face. These are the perspective rules that we need to follow
to create more interesting compositions.

Here, the objects' surfaces above the horizon line relate to it
differently than those below it.

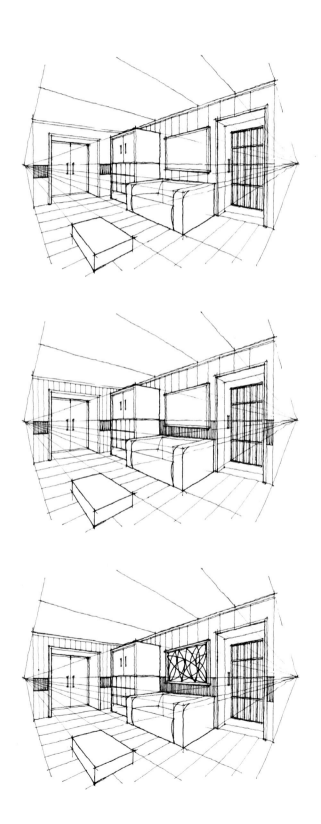

Being aware of the relationship between the surfaces and
the horizon line is critical in creating a good sketch.

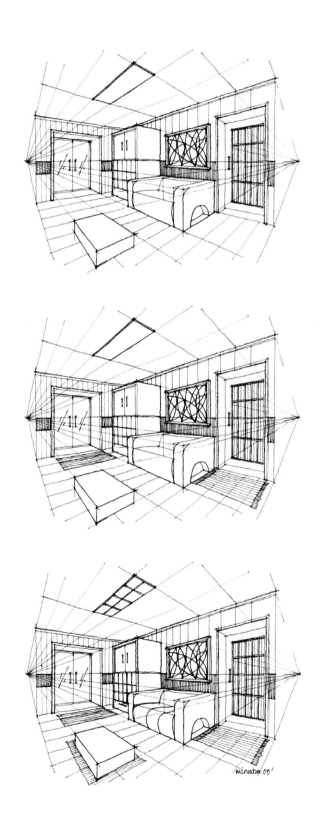

Art Marker Rendering

What ambience is suitable for this room? Many find this a looming issue before colouring their sketches.

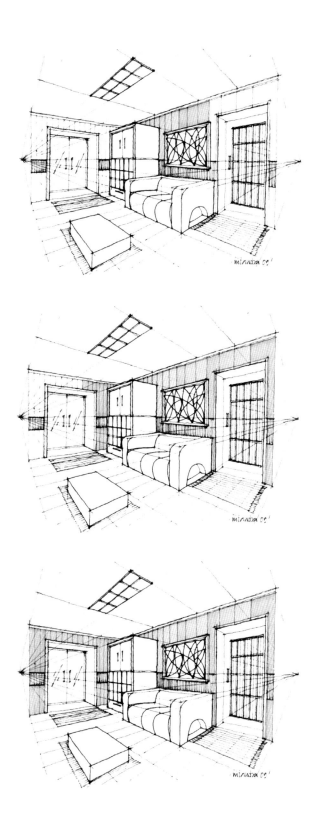

Choosing the right colour is an important skill in creating a
desired ambience.

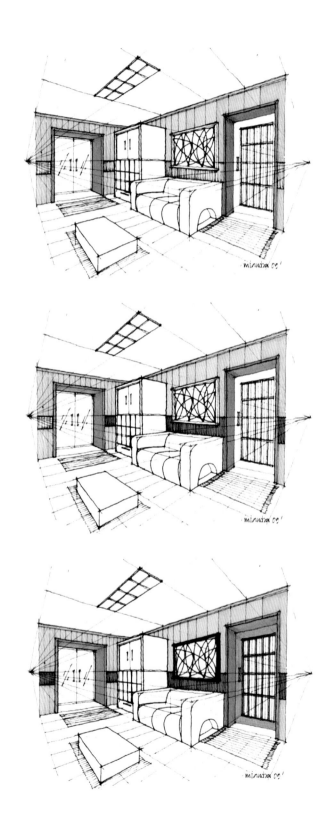

So how does one choose the right colour? The answer is
through careful observation and research.

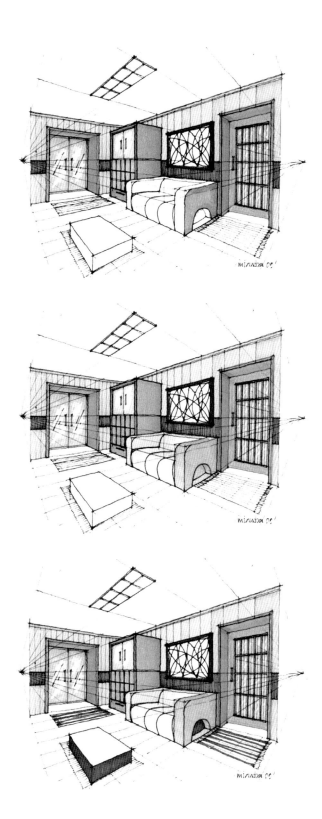

Besides those, we also need to understand some colour
principles such as harmony and contrast in order to form a
strong colour scheme.

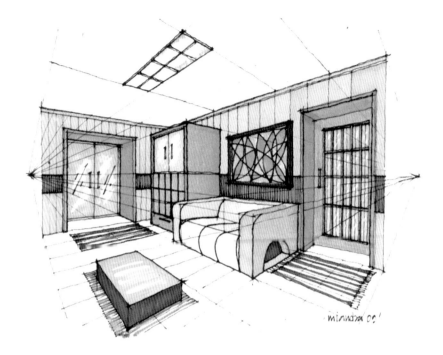

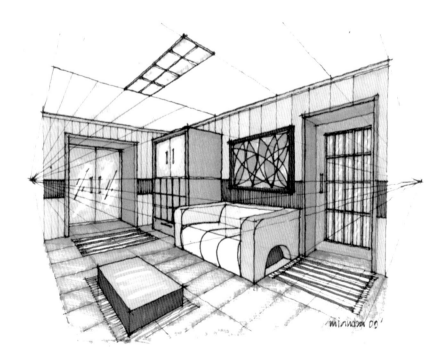

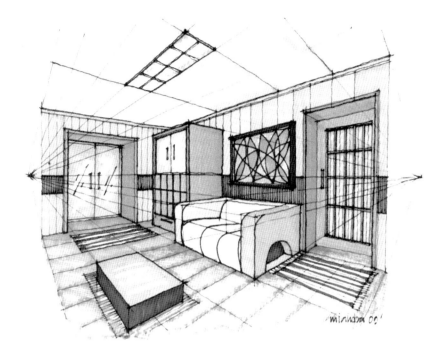

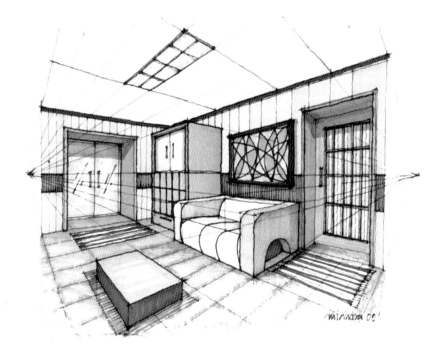

Always remember to be creative when applying colour to create the right ambience.

Pen Rendering

The most common obstacle faced when rendering with a
pen is deciding on the most appropriate thickness of the
lines drawn over the sketch.

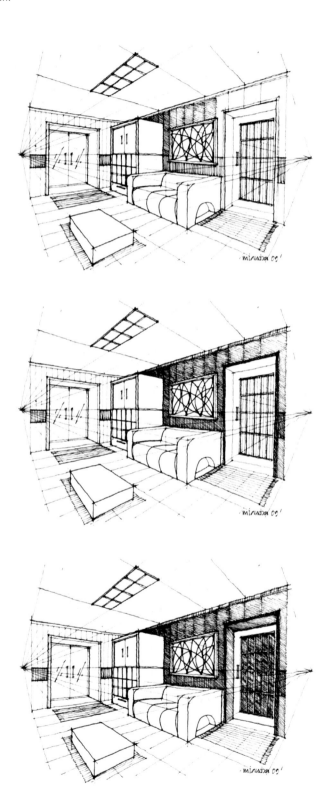

In this example given, look at the thickness of the lines applied to the walls: a dark ambience is created from layers of hatching.

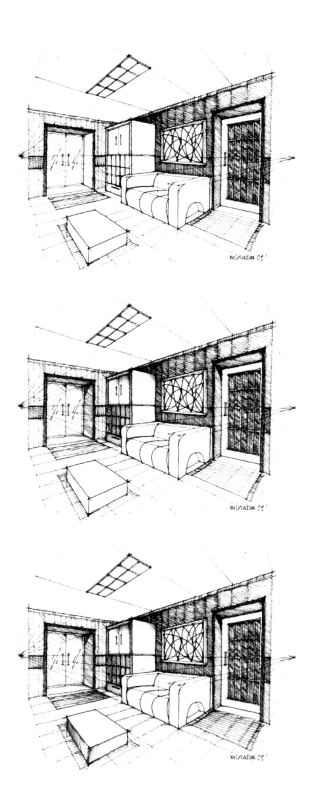

Can you see that some walls are darker than others? This type of ambience was created by using light gradience.

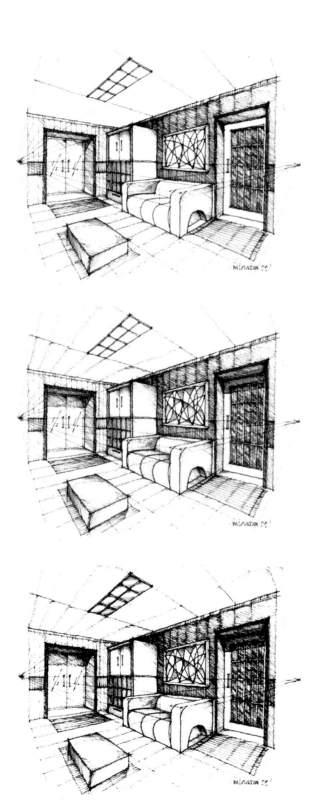

This is the result of careful shading and shadowing.

HOW TO DRAW A TERRACE GARDEN

When sketching many objects from a single view, it is best to create a master view as shown here.

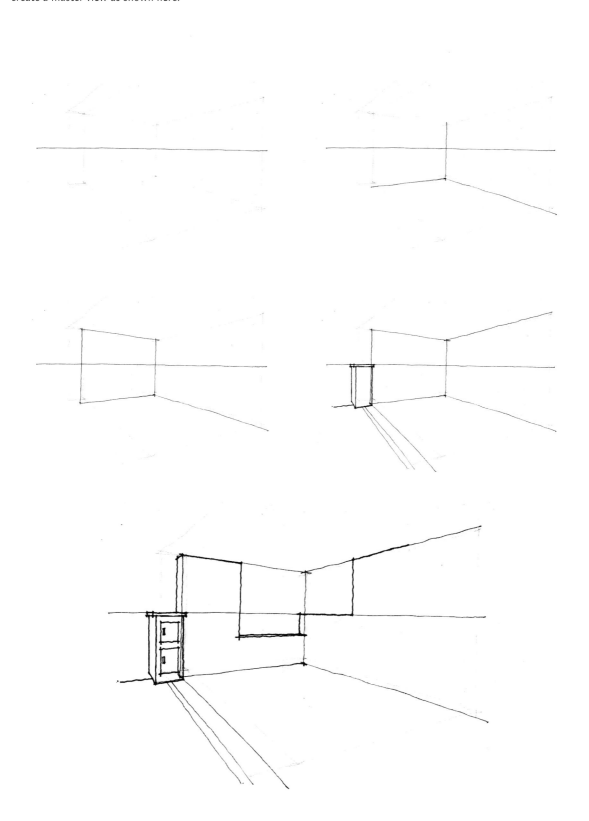

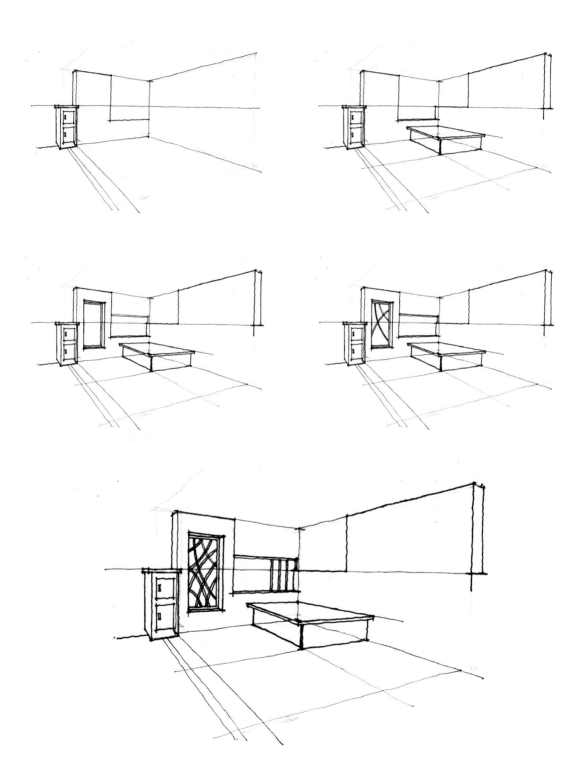

Grid lines act as a good guide for drawing objects.

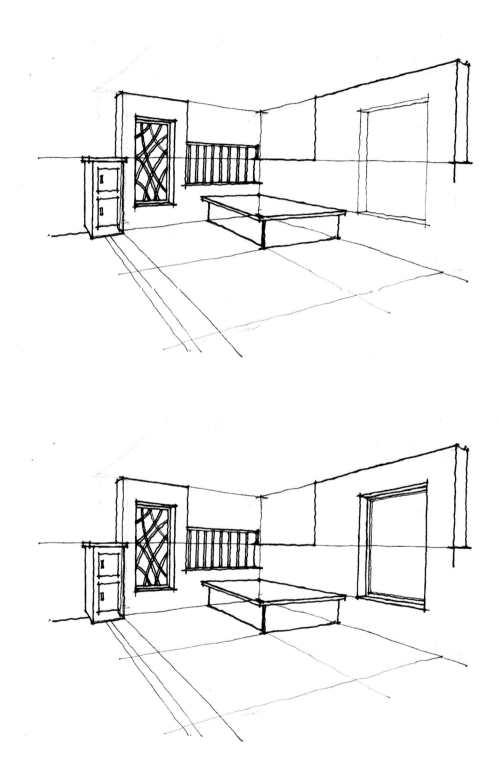

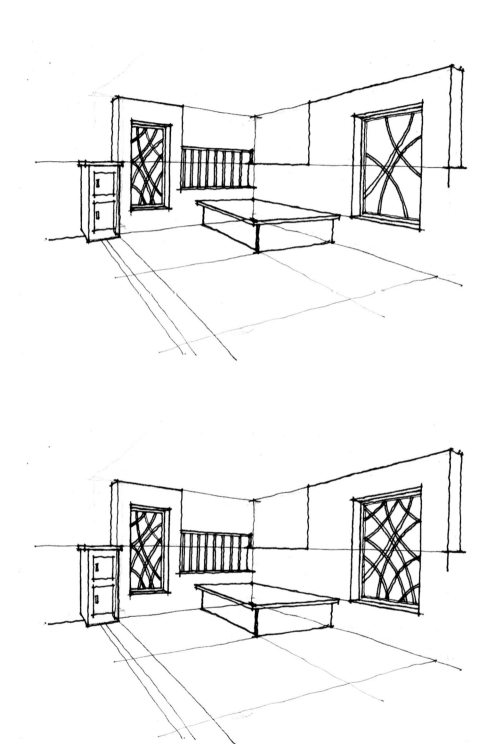

These grid lines were constructed from the two vanishing
points that could be seen within the composition.

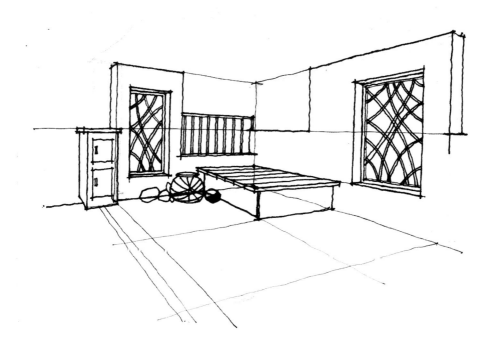

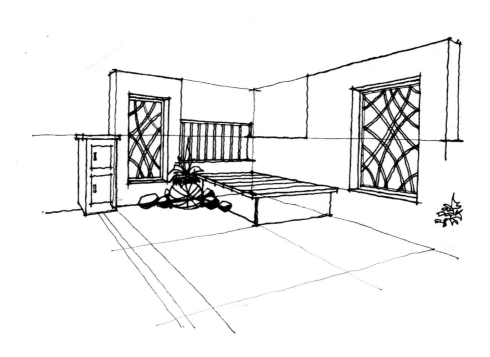

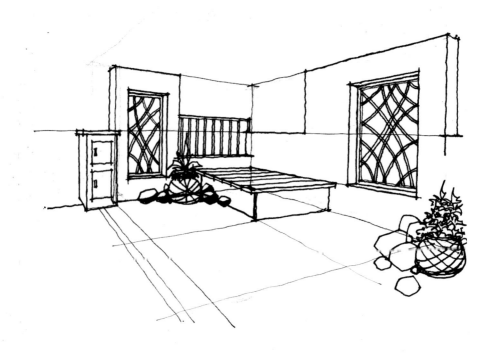

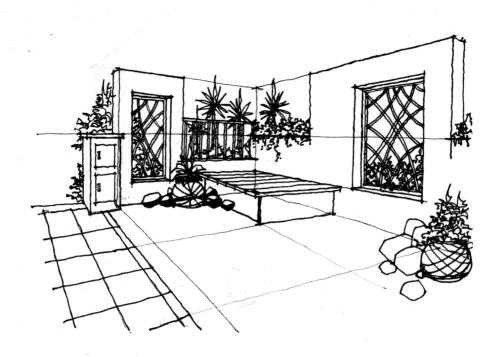

As a result of drawing the objects based on the grid lines,
this sketch possesses good scale and proportion.

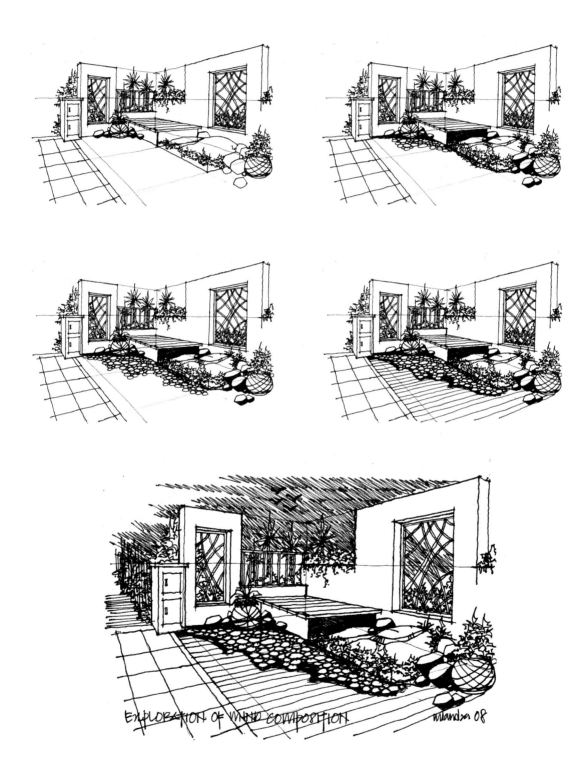

EXPLORATION OF WIND COMPOSITION rolandson 08

HOW TO DRAW A STREET

Did you know that a simple two point perspective can create a complex composition?

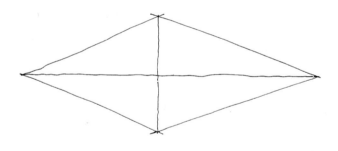

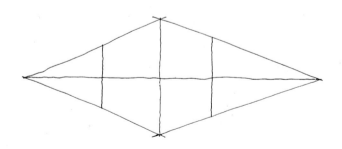

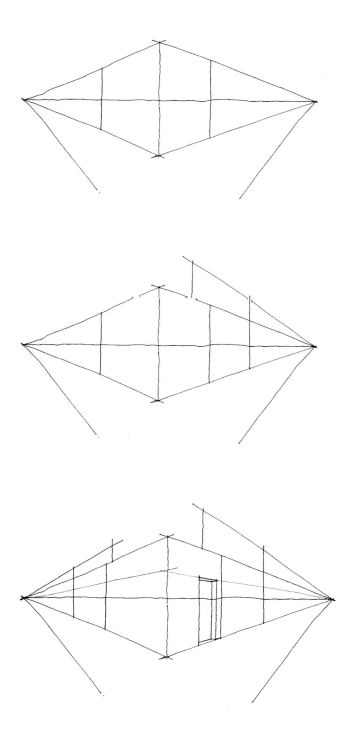

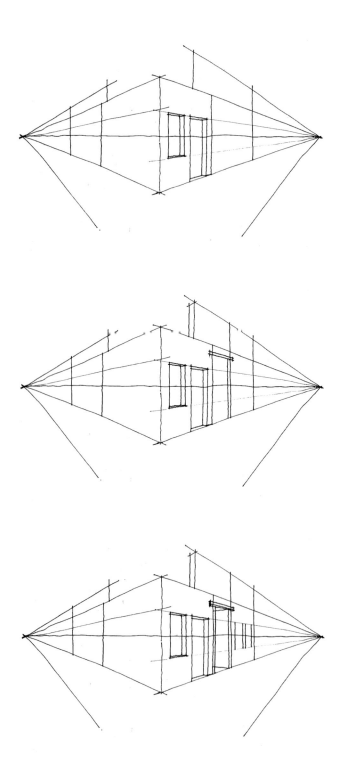

The following carefully illustrates the process of creating a complex sketch composition starting with a simple perspective setting.

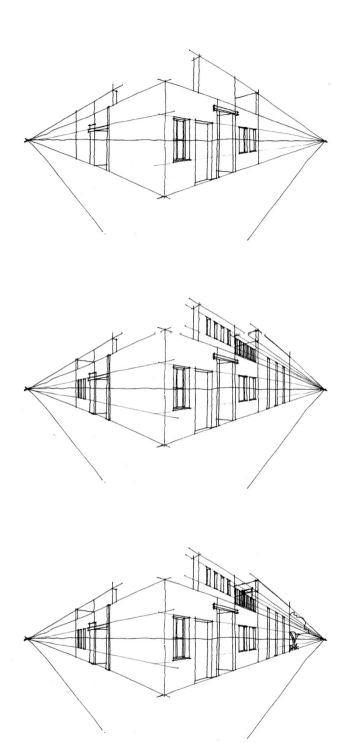

Observe this step-by-step process, paying attention to how the complex composition is derived from lines – a guide to introduce more objects. Meanwhile, the perspective rules and procedures remain constant.

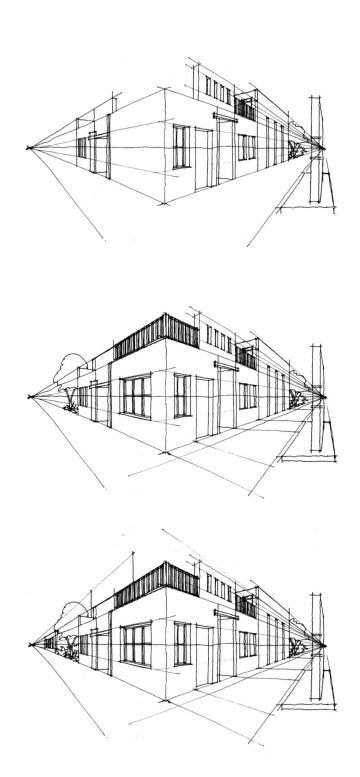

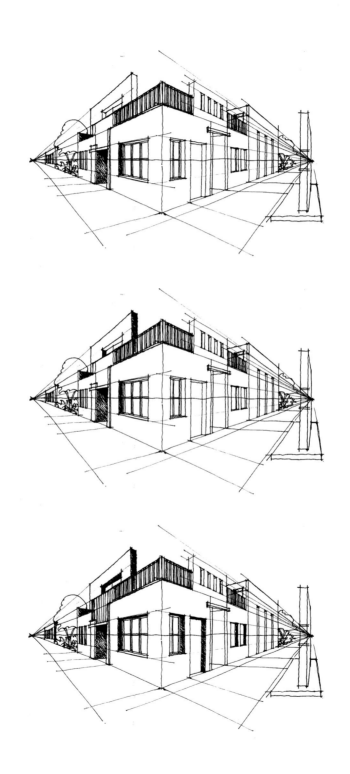

Is this a complex sketch composition? The answer is entirely dependent on our imagination. With more practice, this type of composition will seem increasingly simpler and easier to execute.

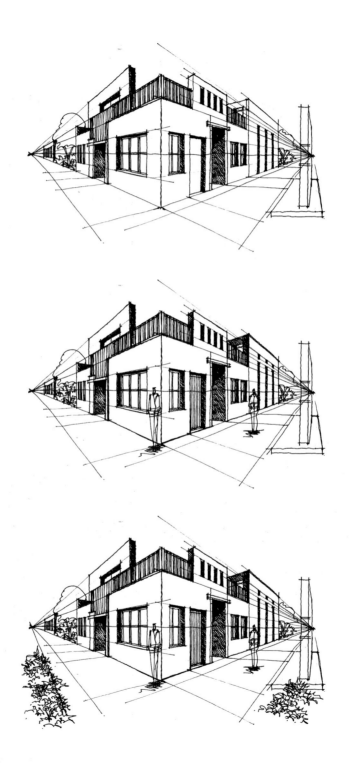

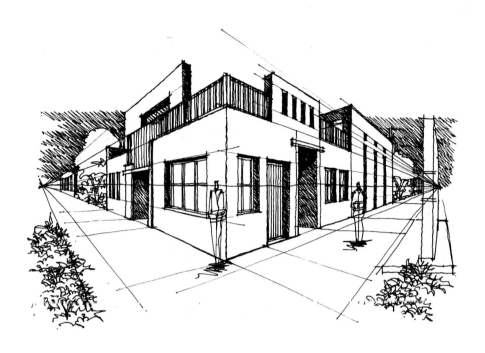

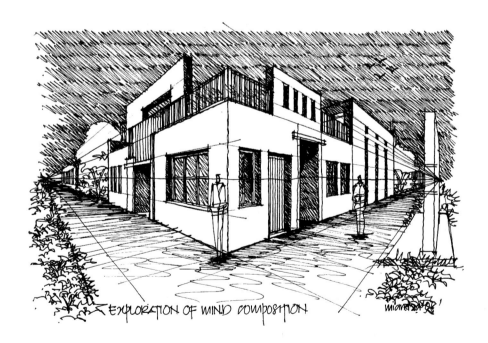

EXPLORATION OF MIND COMPOSITION

This is the final sketch using a two-point perspective, with the imaginary box as a guide.

ATYPICAL PERSPECTIVES

This perspective demonstrates how to draw steps and deal with multiple planes in two point perspective.

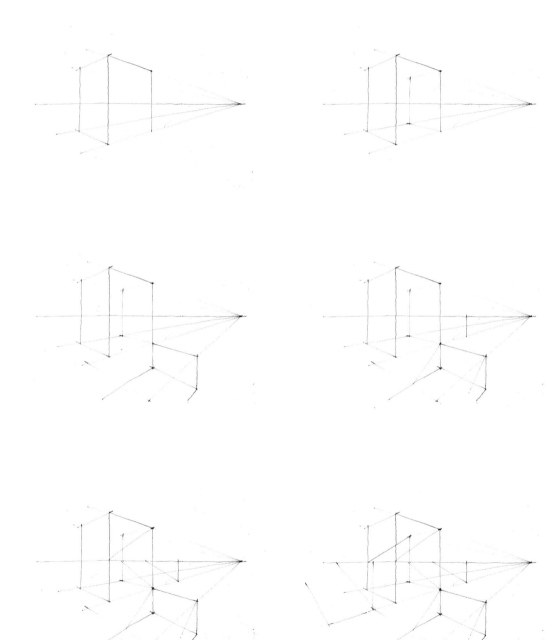

Look carefully at the imaginary boxes and how they help to
justify the position of the various steps and planes.

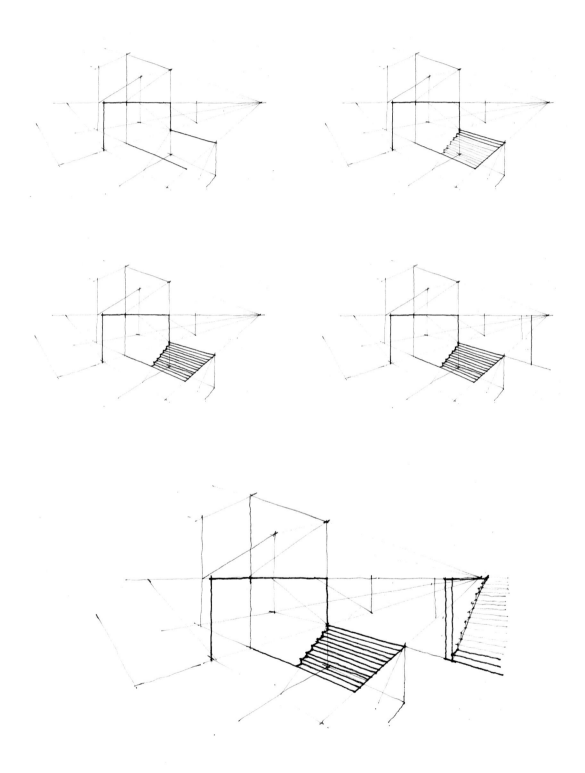

The second vanishing point is hidden outside the composition here. But it is still a point to be referenced to in order to execute this composition proportionately.

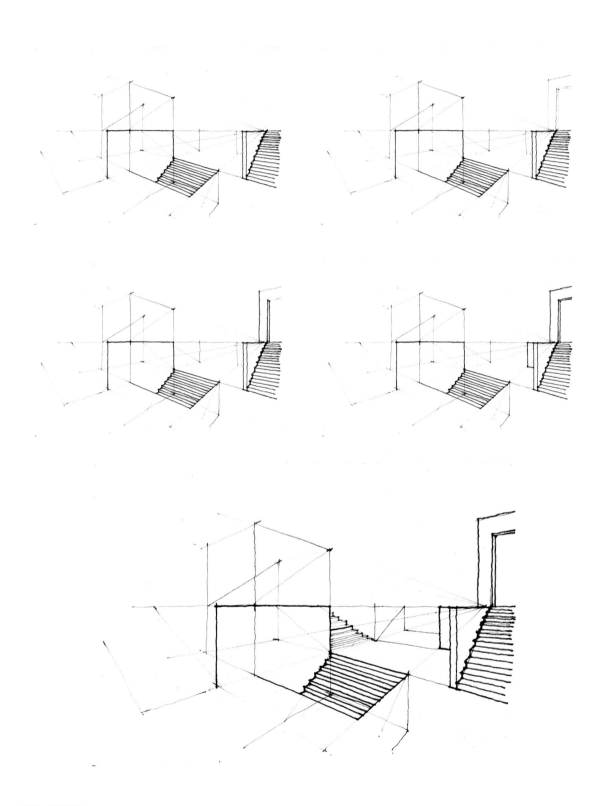

Then, continue to draw lines over the stairs. Be very careful when inking the lines as a single mistake can make a big difference.

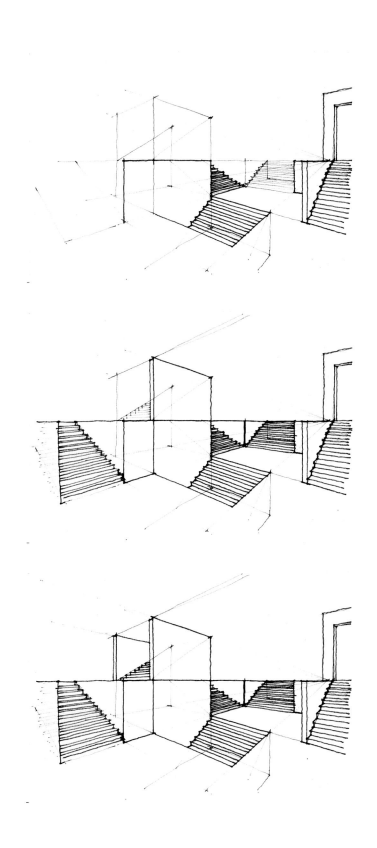

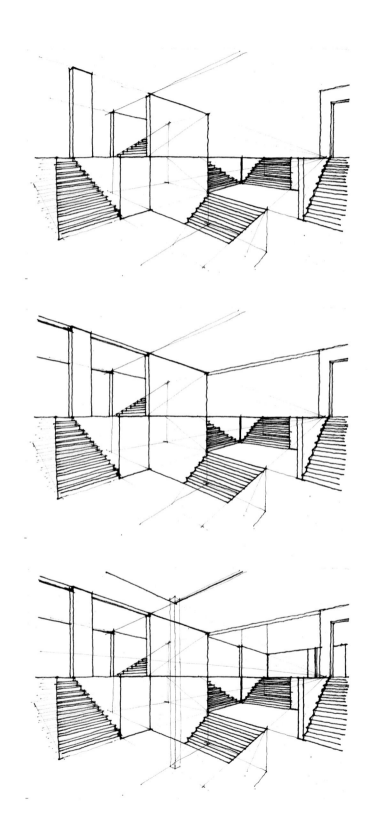

Observe the rendering carefully and identify a mistake that was made during the setting of the perspective line (and not from the inking process).

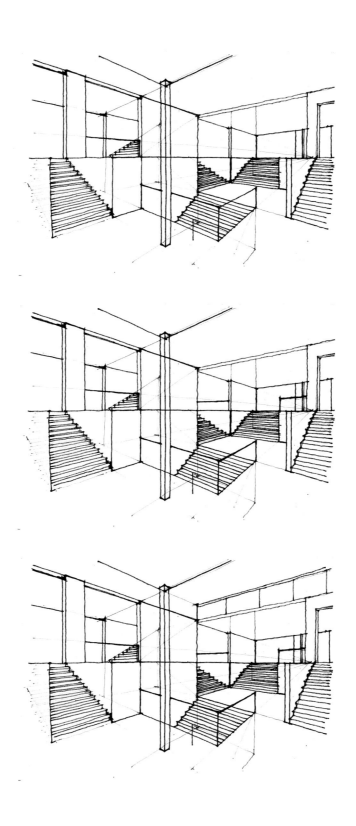

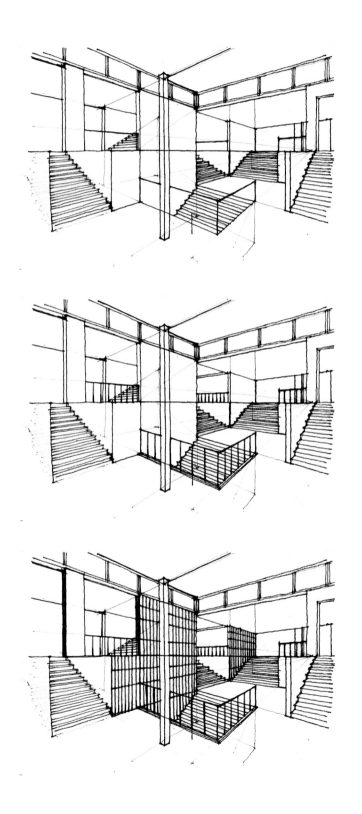

The mistake slowly disappears as the rendering progresses, camouflaged by the object's lines. However, an observant artist who deeply understands the principles of perspective will identify the error easily. Test your eyes and see if you can spot it.

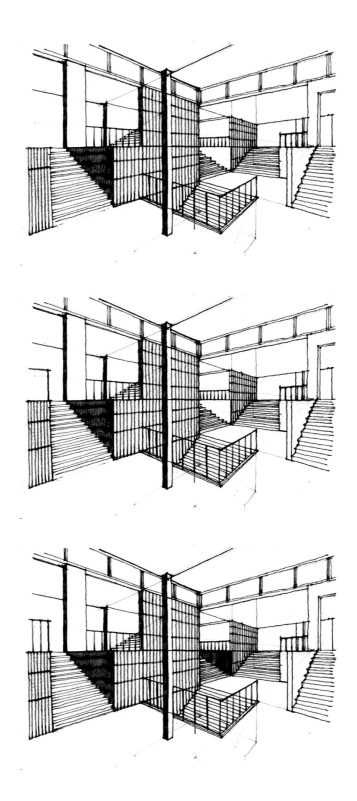

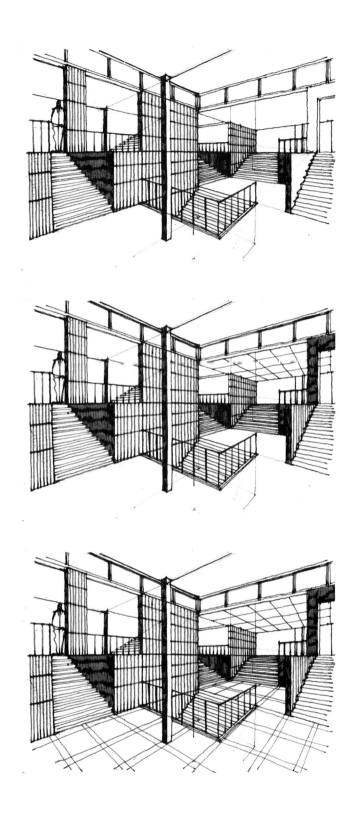

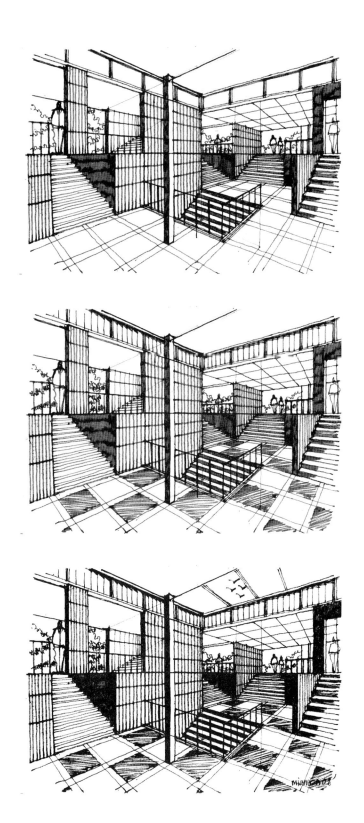

Have you found the mistake yet? Let others try to find it as well. Have fun!

CHAPTER 4

THE IMAGINARY BOX IN
MULTI POINT PERSPECTIVE

Our view of everyday life will often be from a multi point perspective compared to other perspectives. Now, what exactly is a multi point perspective? It consists of three or more vanishing points and characteristics such as the horizon line, vanishing point setting and eye level are similar to its counterparts. Take a look at your surroundings and see if they are from a multi point perspective.

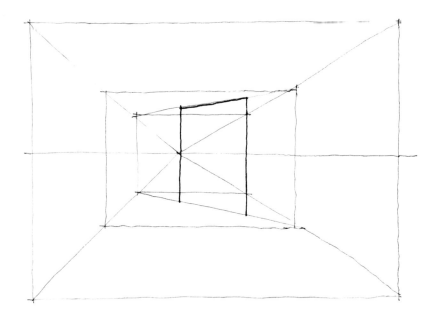

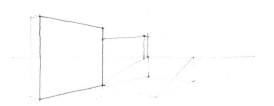

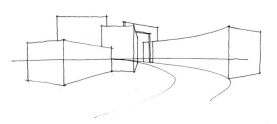

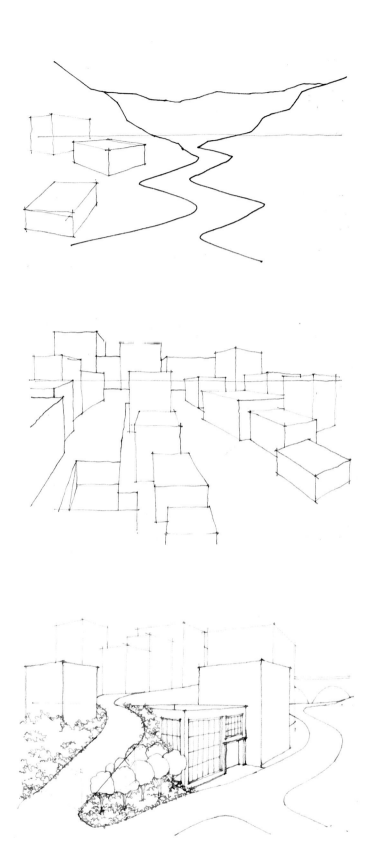

These are some scenes illustrated in multi point perspective.

HOW TO DRAW A ROOM

Start by setting up the multi point perspective using either one or two point perspective. Look at the example given where a one point perspective has been set.

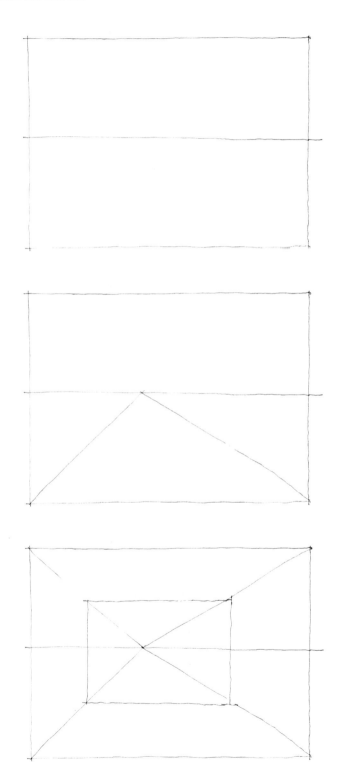

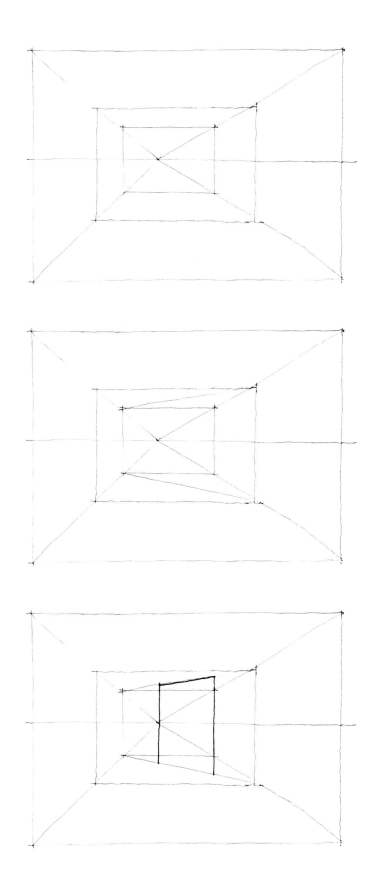

The multi point perspective approach was then used after a wall, not parallel to the horizon line, was introduced into the composition.

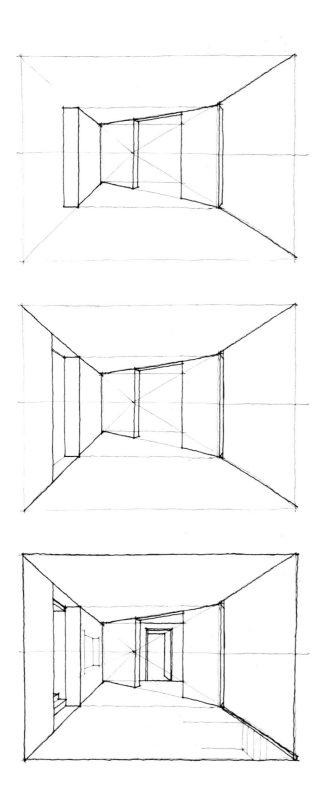

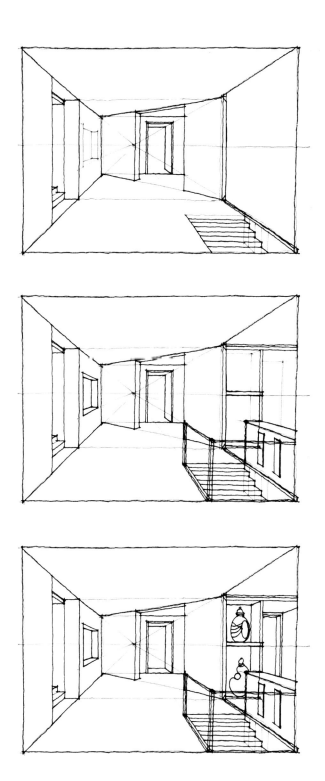

Consequently, the stairs were introduced into the room, and another set of vanishing points was used to adjust to this addition.

A few other elements were added to the sketch. Test your understanding of the multi point perspective by identifying them.

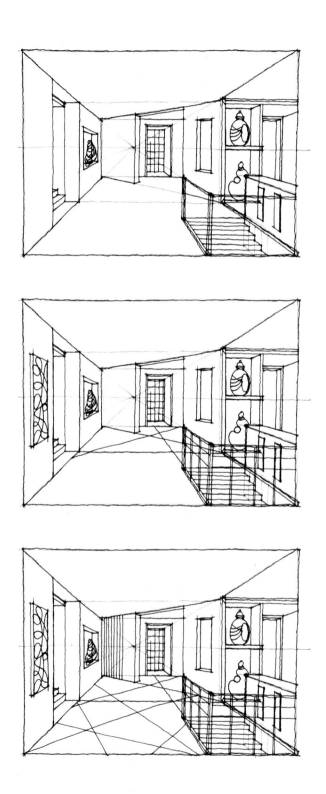

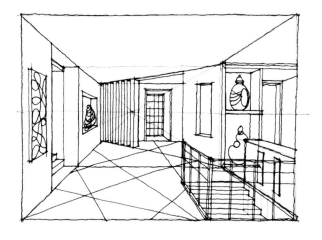

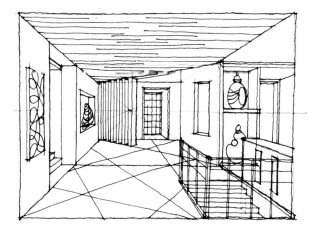

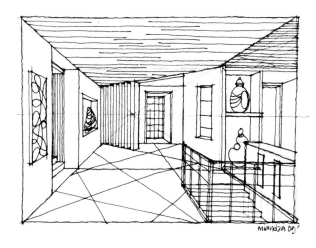

If you have correctly identified them, they would be the tiled flooring, the painting, the fin wall and the items on the shelves.

Art Marker Rendering

Reminder: Do not throw away old art markers as they can be used for rendering. Observe how these renderings were done to produce some effects on the composition.

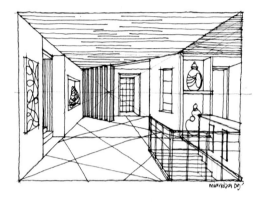
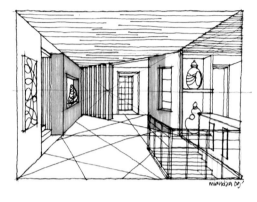
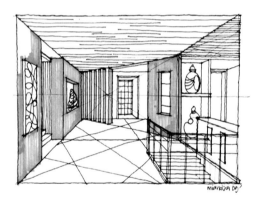
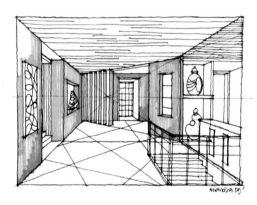
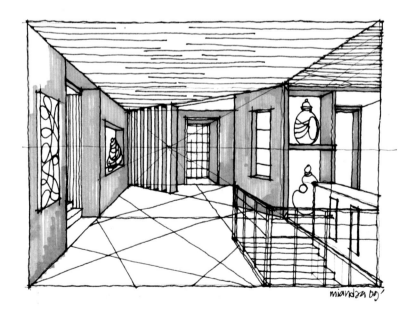

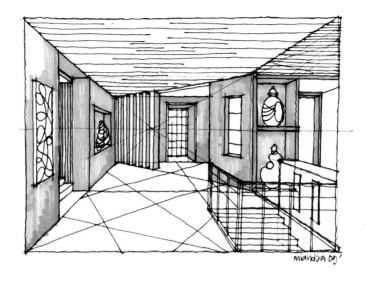

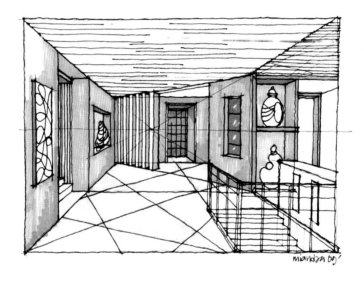

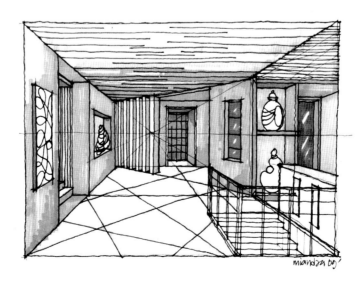

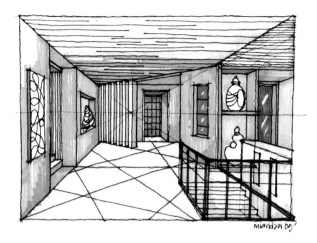

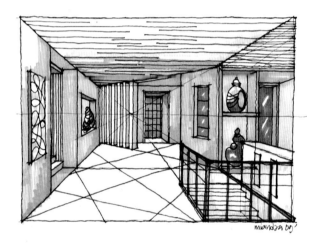

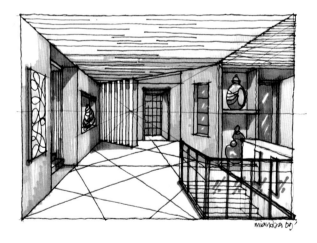

This is the final art marker rendering. It is the result of a combination of new and old art markers, creating a pleasant ambience for the overall composition.

HOW TO DRAW A GARDEN (A)

These are three garden sketches created using the same
multi point perspective.

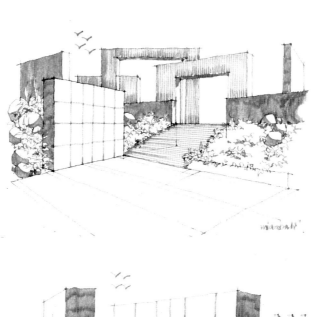

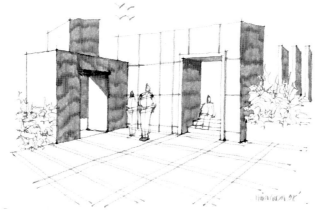

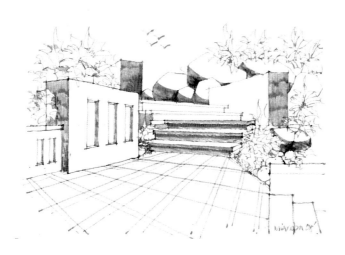

HOW TO DRAW A GARDEN (B)

Let us try our first garden sketch using the multi point perspective. The horizon line plays an important role in setting the eye level.

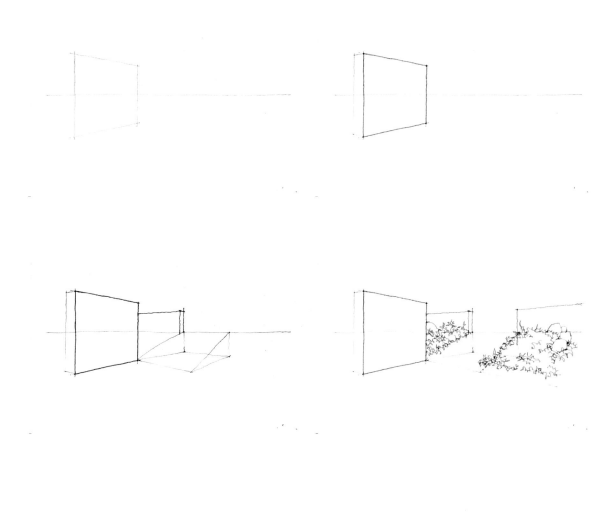

Tip 21: The objects' scale and proportion always influences the eye level of a composition.

This is from an adult's eye level (1.5 meter height) while taking into account the scale and proportion of its objects.

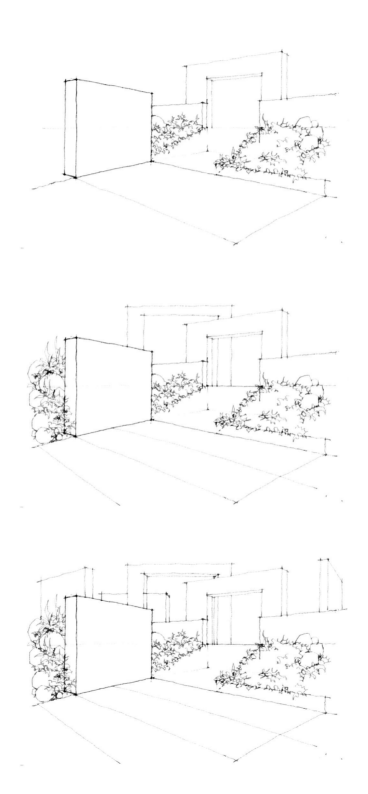

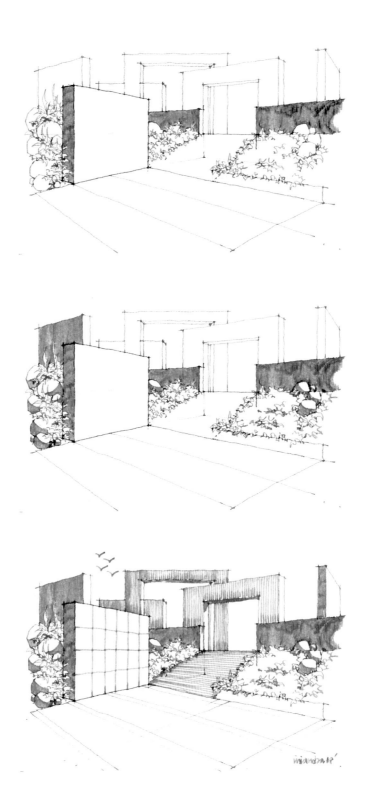

HOW TO DRAW A GARDEN (C)

This is the second sketch composition using the same perspective. Observe the change in the eye level between Garden (a) and (b) relative to the scale and proportion of the objects in each of them.

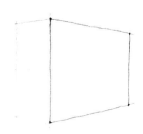

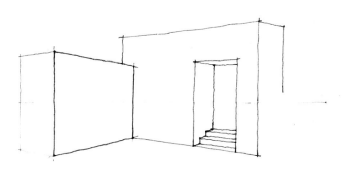

Tip 22: The eye level of a sketch can be determined by the horizon line or according to the objects' scale and proportion.

This is from a child's eye level (1.2 meter height) which takes
into consideration the scale and proportion of the objects.

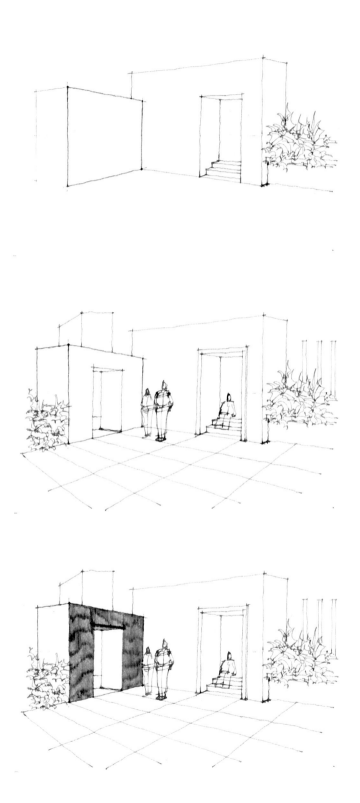

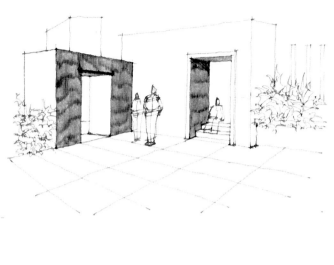

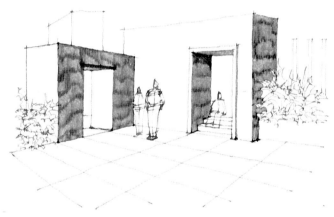

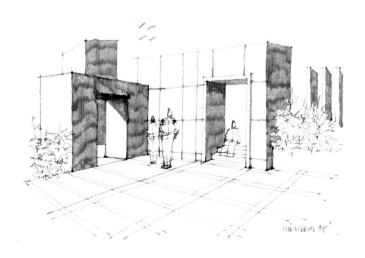

HOW TO DRAW A GARDEN (D)

The third sketch composition was done based on a smaller child's eye level. Observe differences in the scale and proportion of the objects drawn here as compared to the sketch at the adult's eye level.

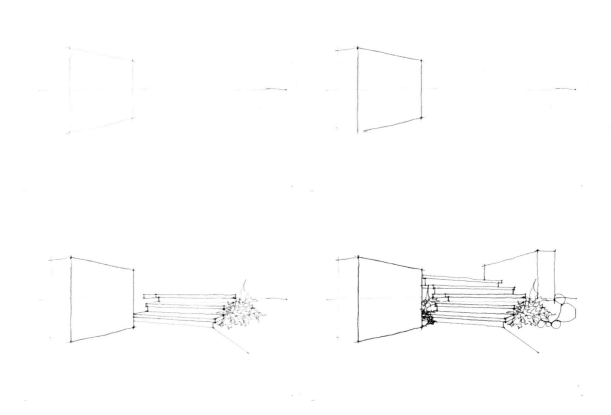

Tip 23: It is possible to change the eye level without having to change the height of the horizon line, but the objects' scale and proportion will be altered similarly.

It is clearly illustrated that the objects' scale and proportion influences the height of the eye level. The eye level created was meant for a child with a height of 0.8 meter.

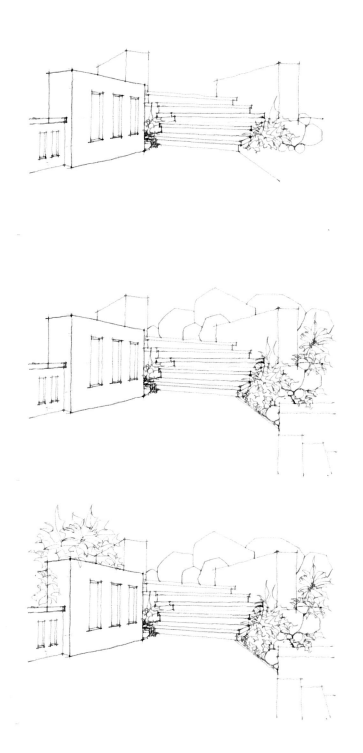

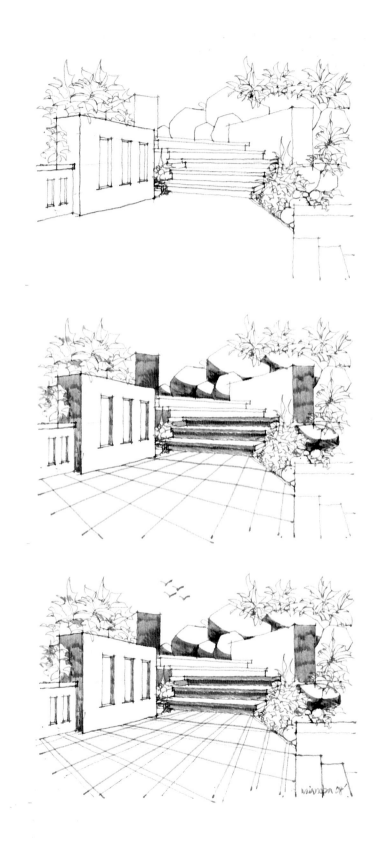

URBAN SKETCH

This is an experimental sketch which explores creating different planes in an urban setting using the imaginary box. Try to examine the following steps that map out the levels and buildings.

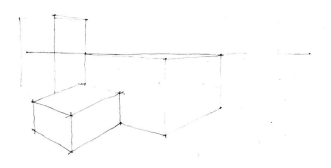

Tip 24: To create different levels in an urban setting, the concept of the imaginary box is a preferred solution for perspective sketching.

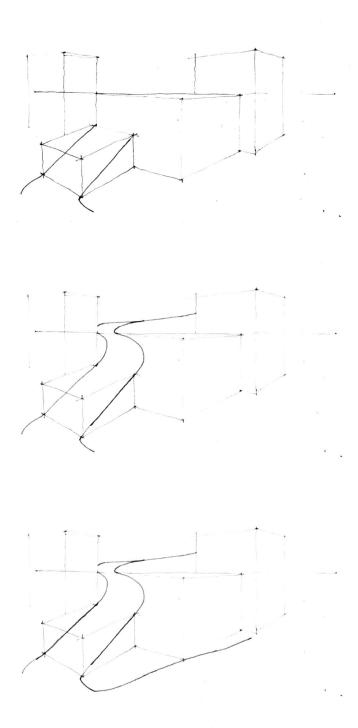

Look carefully at the imaginary boxes drawn to meet at different levels. They will guide you in drawing two winding lines, connecting the two levels.

This is a fairly easy technique that anyone can learn and make use of.

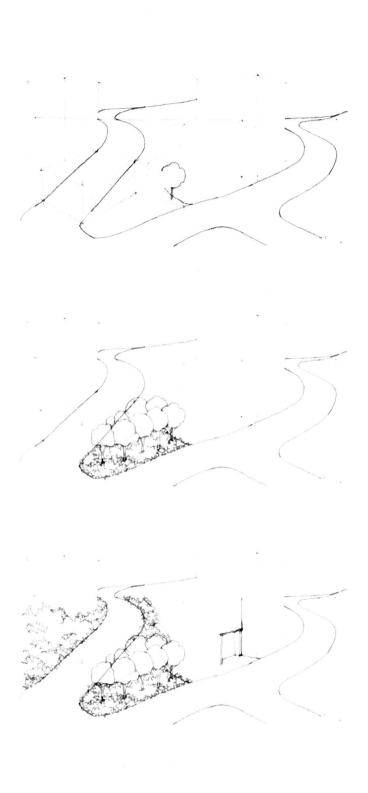

Also, always ensure that the major setting is completed be-
fore any detailed elements are introduced. Can you identify
any detailed elements?

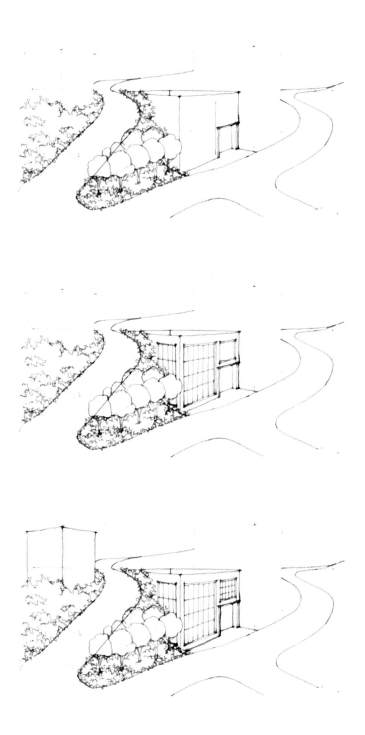

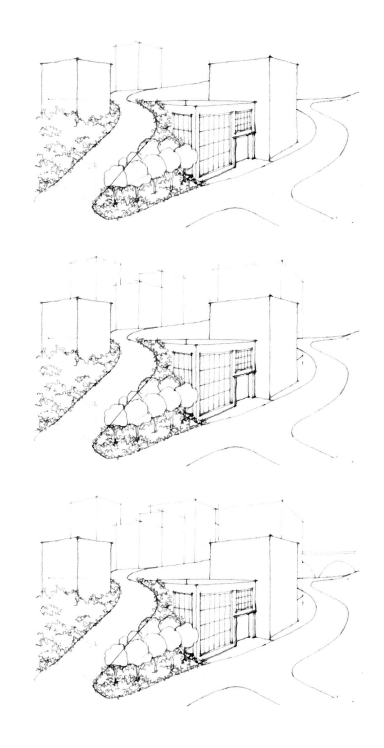

These detailed elements include the landscape setting, the buildings' facade and the bridge. Adding such details strengthen the aesthetics of the environment.

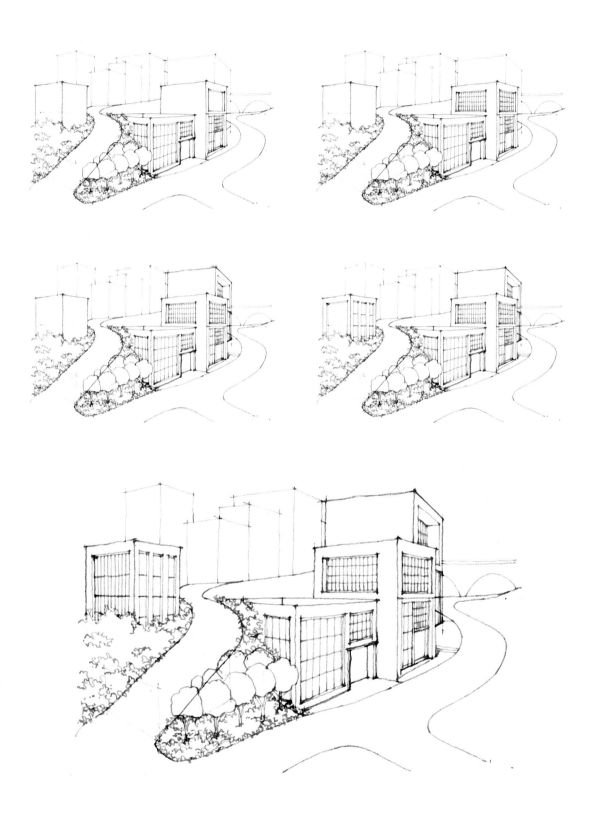

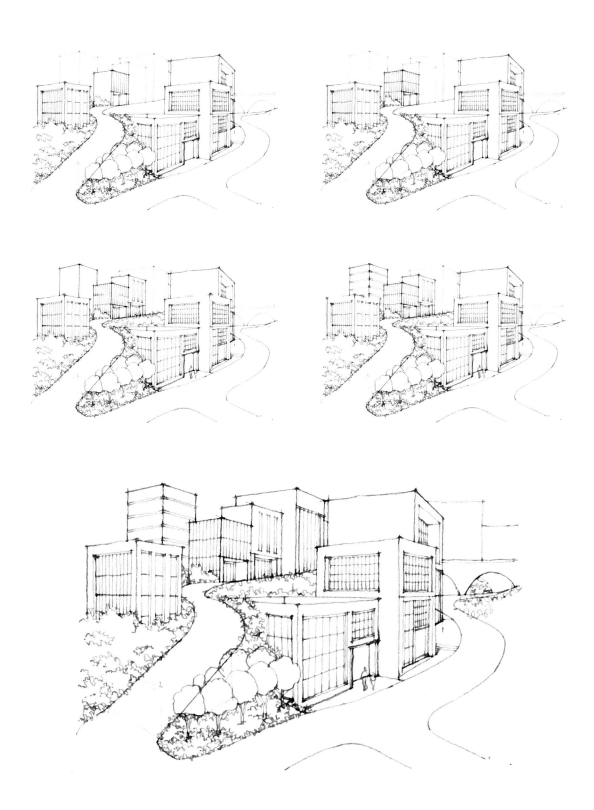

Pen Rendering

This process is crucial in making a good impact and adding accents to a finished piece.

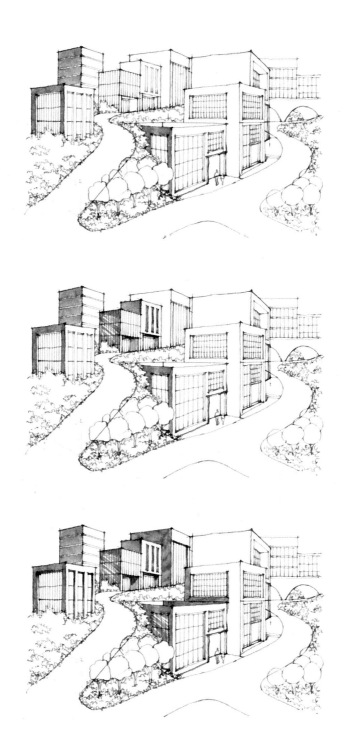

For this sketch, a hatching technique was used with special ink.
However, we hardly see the hatching effect as a result. This is a
'flat' effect demonstrated when a fountain pen is used.

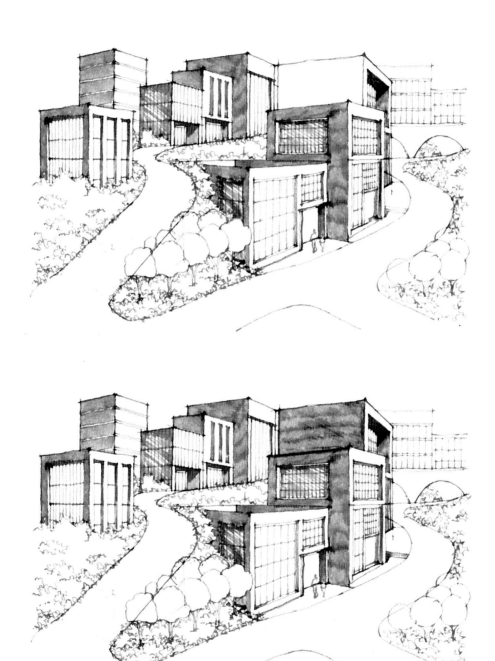

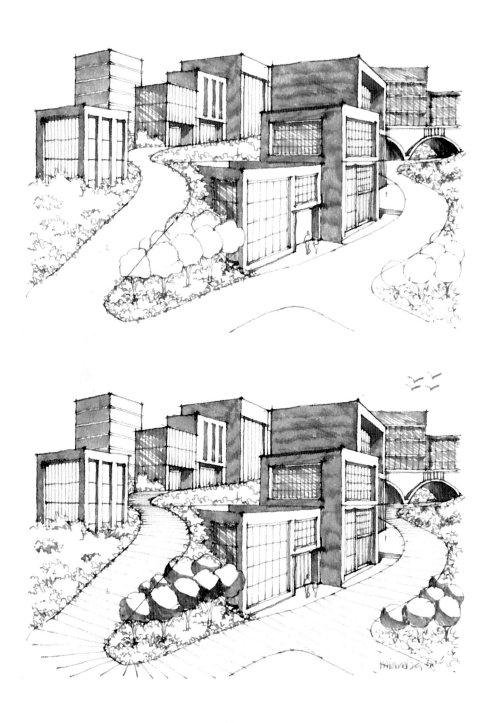

HOW TO DRAW A TOWN

Before preparing for any sketches, one needs to do a little
research to have a clear idea and visualisation of the town.

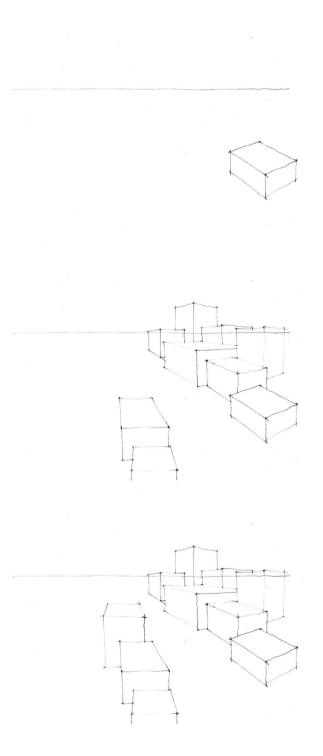

You need to confirm certain information such as the type of town, its images and characters from a human's point of view or a bird's eye view, especially its detailing. Sometimes, you need to have more information than those mentioned in order to start sketching.

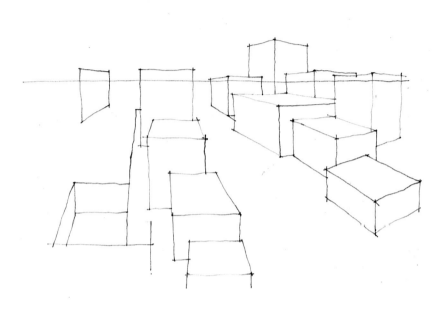

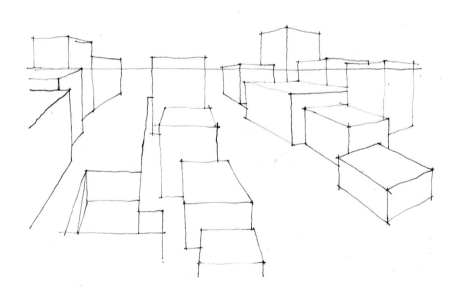

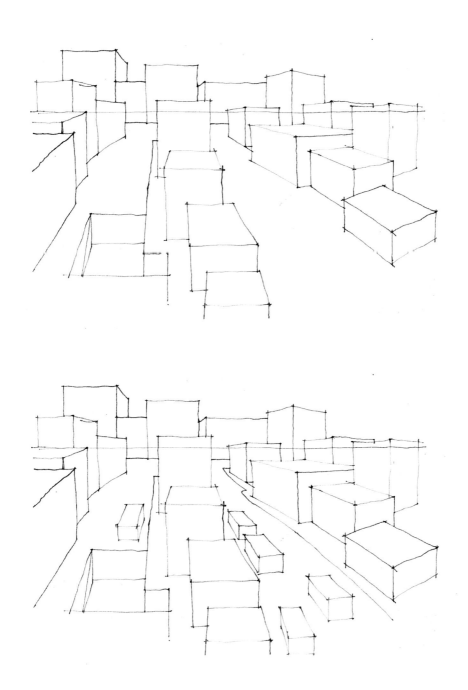

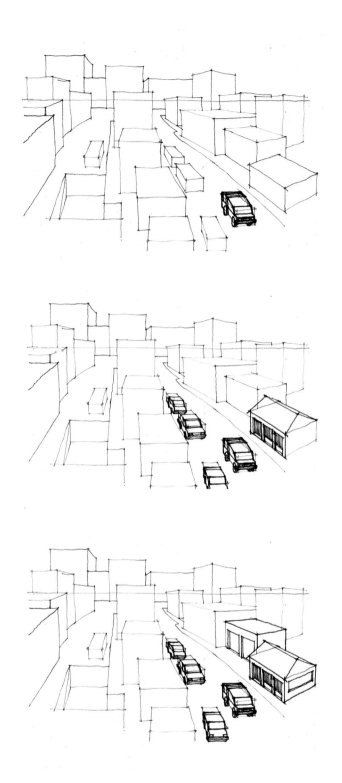

Tip 25: General information related to objects or sceneries are important in creating an accurate sketch.

Observe the step-by-step process of drawing the details on
the buildings and streets after completing the initial layout.

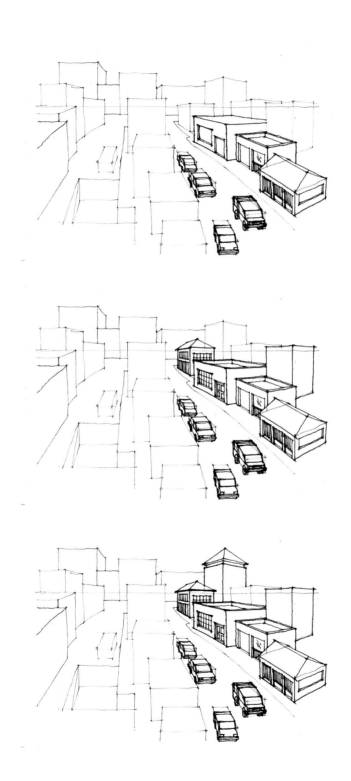

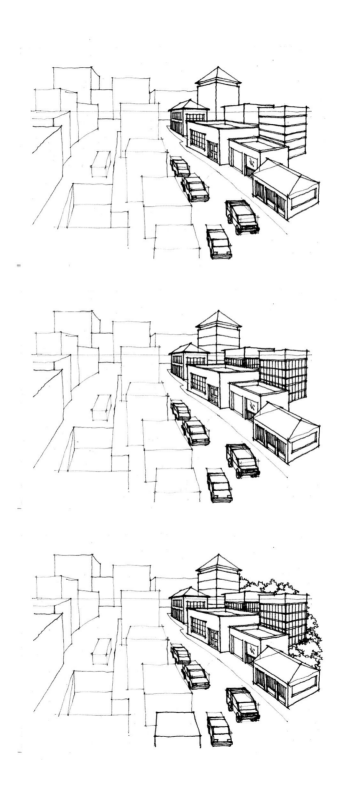

How do we go about collecting information about a town? It can be gathered from many sources such as magazines, experiences, the internet's image databases and an infinite number of ways if you are willing to spare the time for careful research.

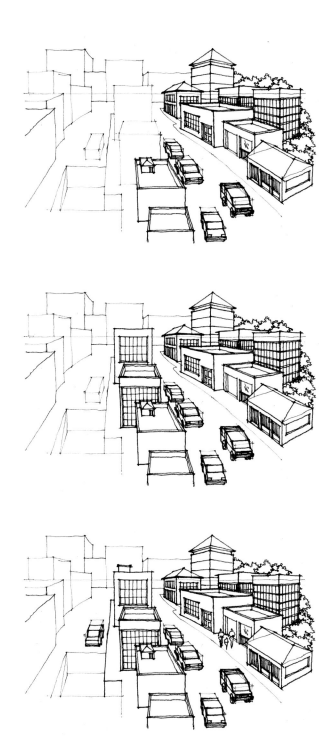

Now, how do we make use of gathered information? You can print them out as visual references during sketching, or infer from visual elements and ideas from your other research.

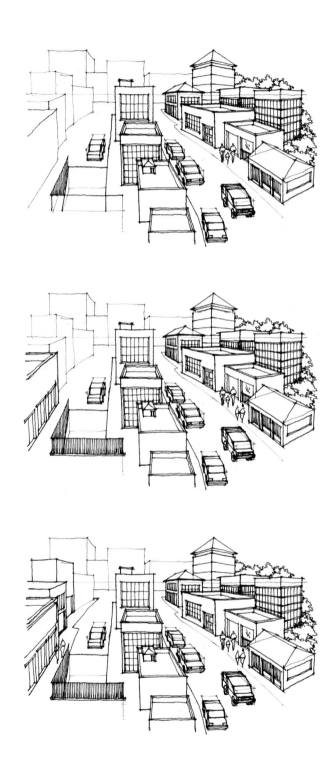

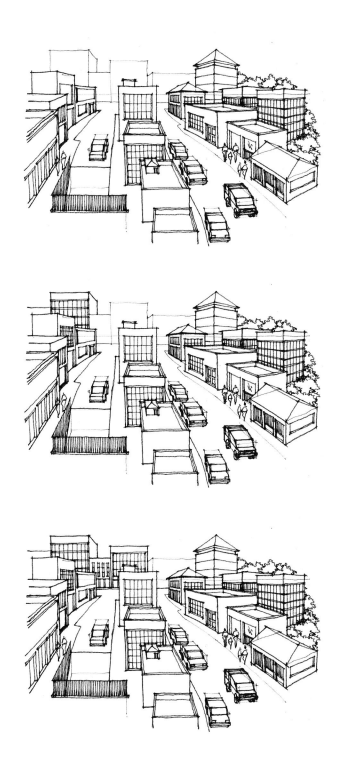

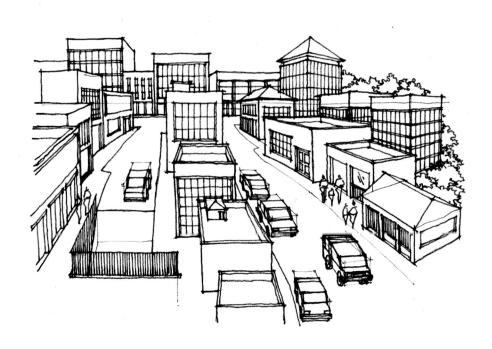

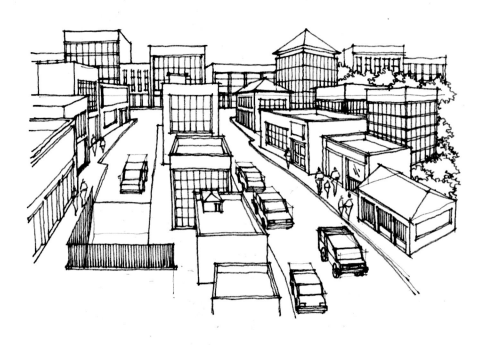

Pen Rendering
This is another example of how a fountain pen and special ink has been used to render a sketch. Gaze upon this rendering and notice some spots that were left out.

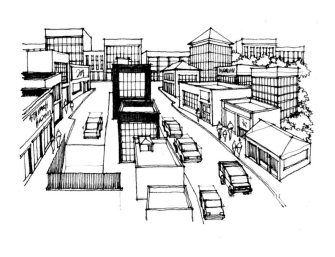

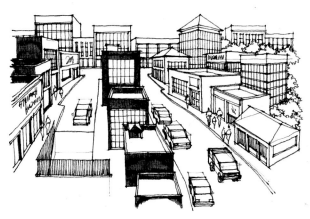

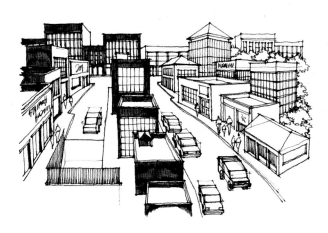

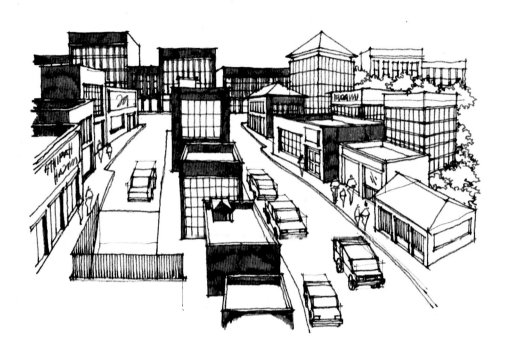

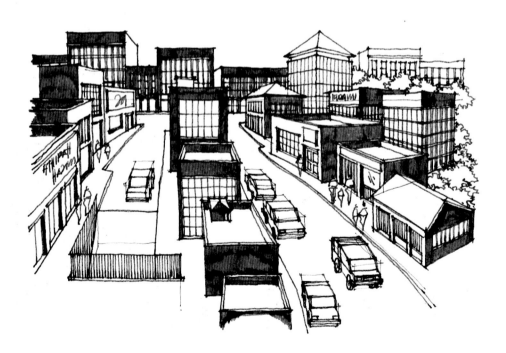

This is an example of a technique in pen rendering that could enhance your sketches.

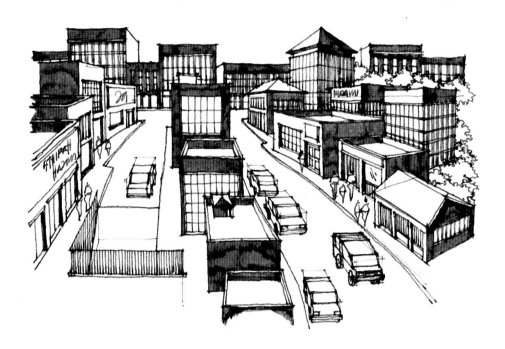

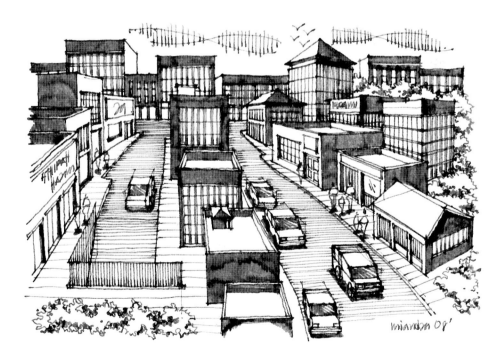

LANDSCAPE SCENERY (A)

When dealing with landscape scenery, always use the multi point perspective as other approaches do not take into consideration multiple angles.

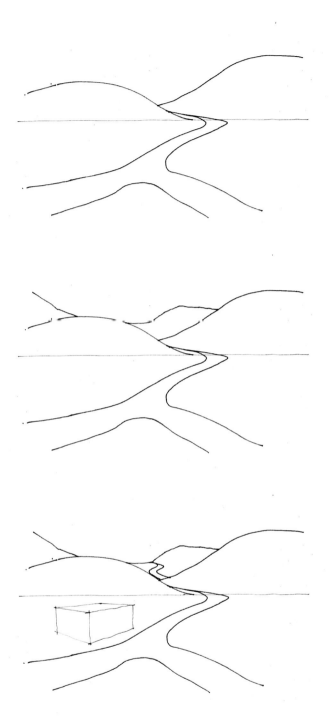

Carefully study the construction of imaginary boxes for a few building blocks in various angles. Without using the multi point perspective, it would be impossible to execute this composition proportionately.

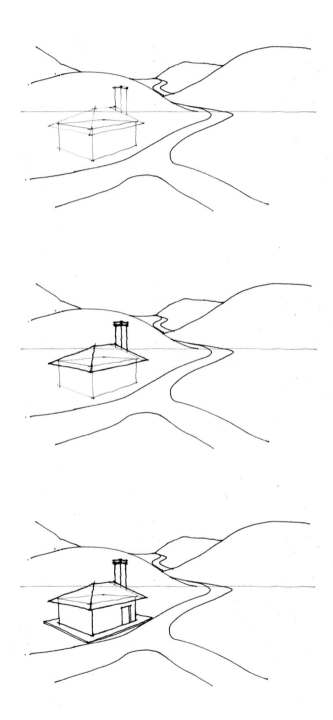

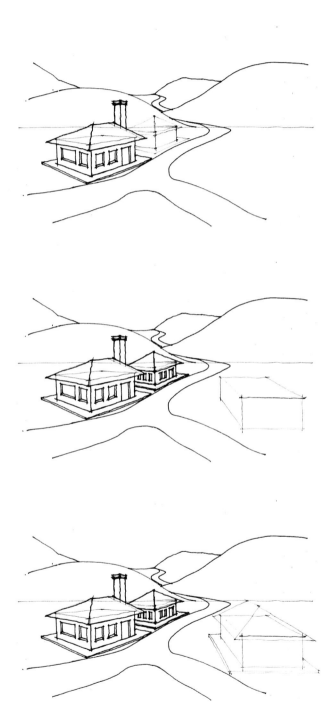

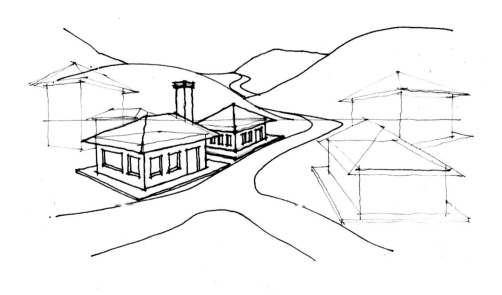

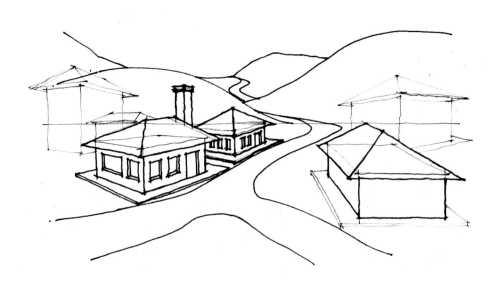

Look at the transformation of the sketch from a wire-like frame structure (imaginary boxes) into buildings with character and detailing, supported by beautiful and natural elements like trees and hills.

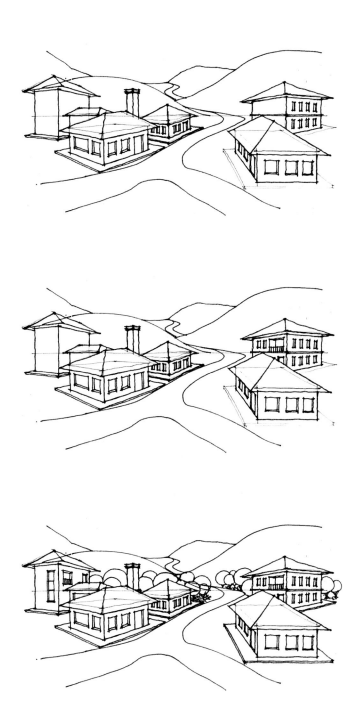

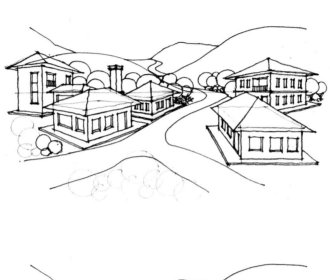

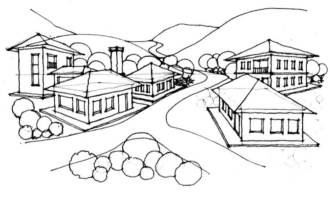

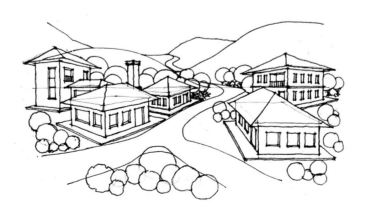

Pen Rendering

Apart from being creative when rendering, we still need to know when to start and when to stop. This is something subjective that needs to be interpreted by the artist.

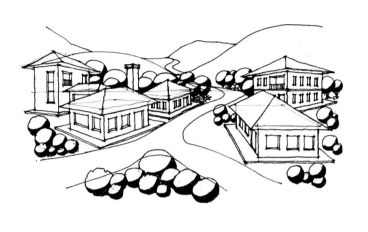

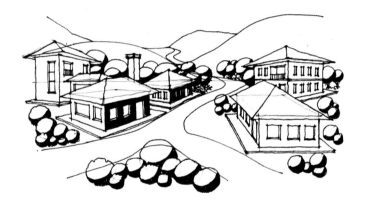

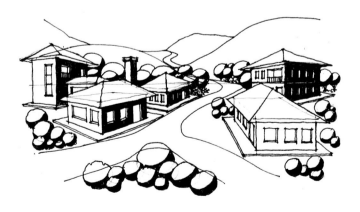

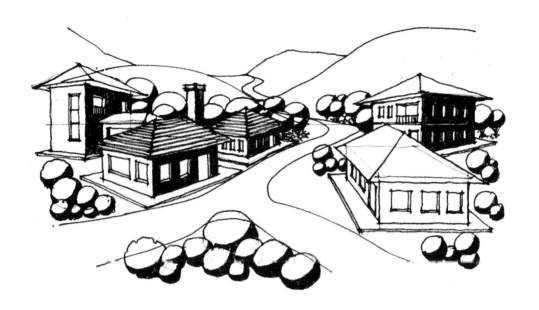

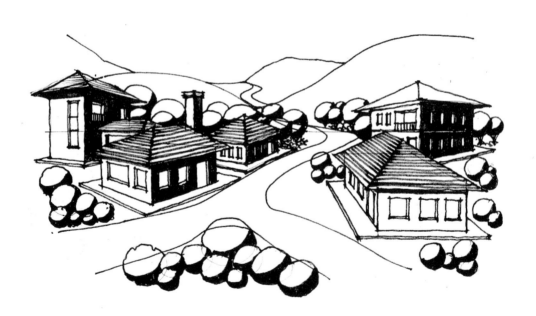

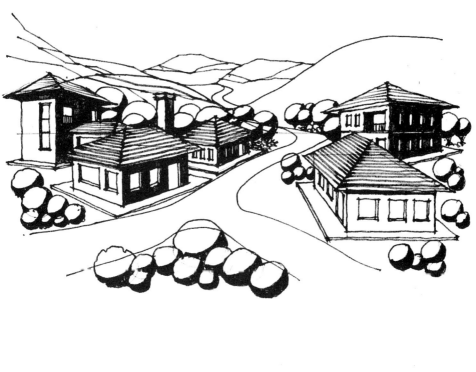

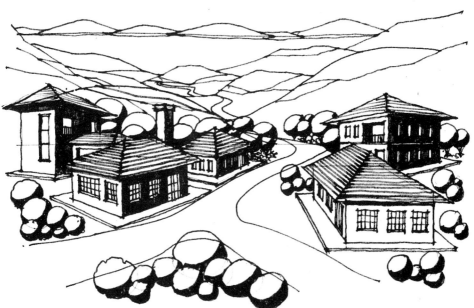

Sometimes, we do not have to render all spots in a sketch composition as even a few are sufficient.

Observe these three steps and notice how only a few rendered portions are enough make an impact on the overall composition.

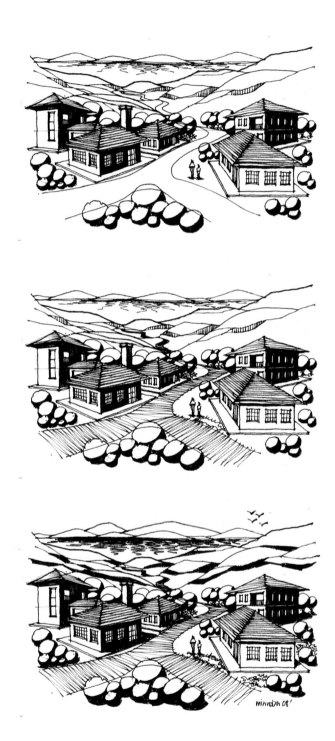

The final composition after the rendering process.

LANDSCAPE SCENERY (B)

This is another example of how the imaginary box plays an important role in multi point perspective sketching.

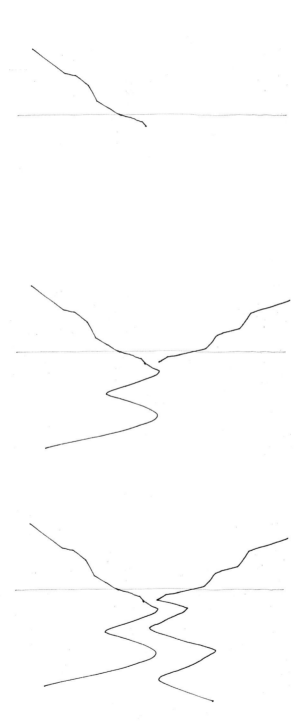

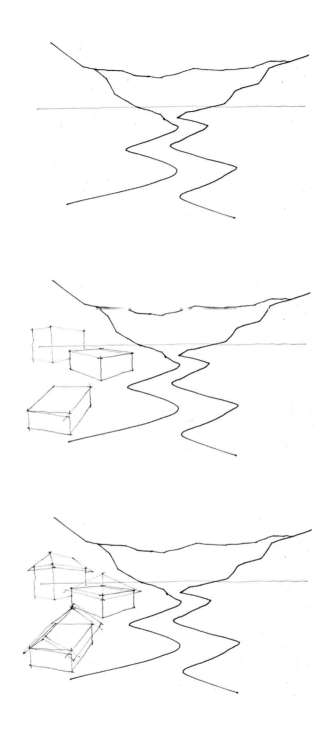

Tip 27: Always remember to refer to the horizon line when drawing lines or imaginary boxes.

The imaginary boxes here were all drawn based on the hori-
zon line as their reference.

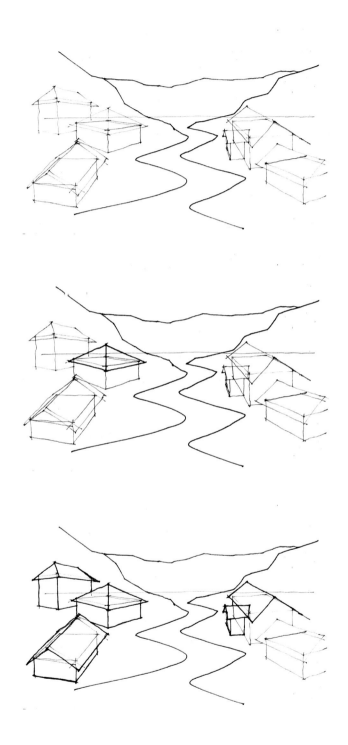

Did you know that imaginary boxes also help in justifying roof
positions and their surfaces in relation to the horizon line?

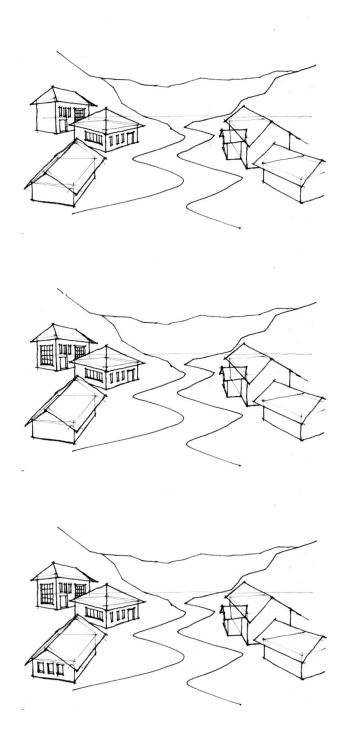

Here, secondary elements are applied to complete the sketch
layout.

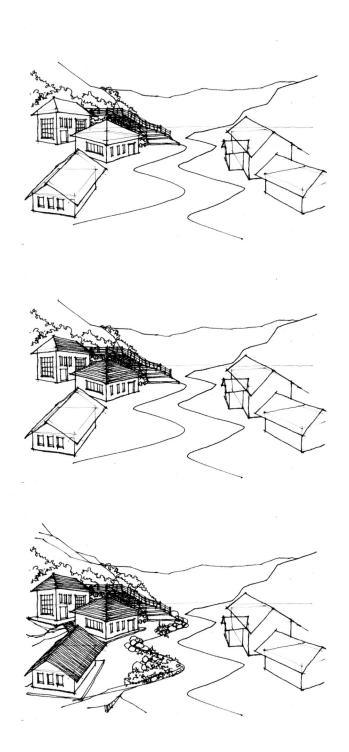

Once the major objects are in place, other minor objects will
be easier to set.

Setting minor objects is dependent on the position of the major ones, forming a complementary relationship between the two.

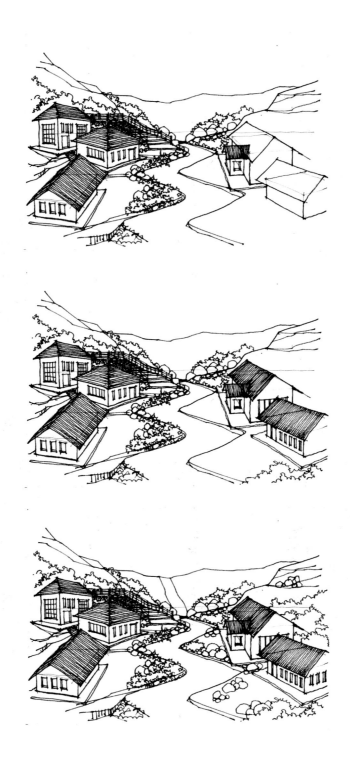

You can see that the buildings (major objects) and the trees (minor objects) seem to complement each other well within the composition.

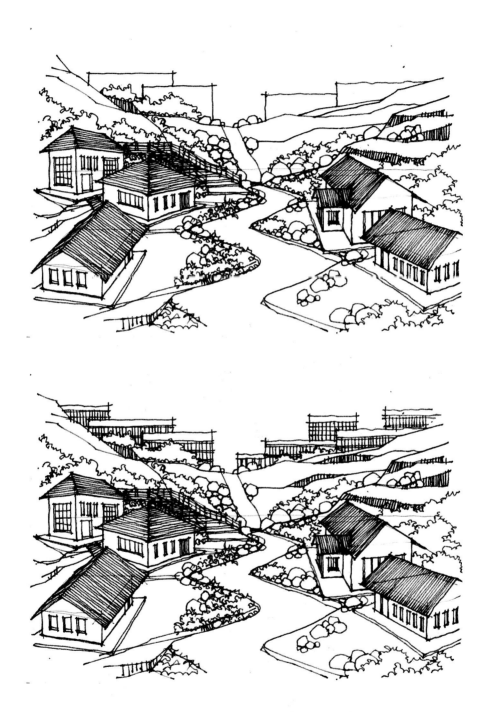

The last step is to render the sketch composition according
to how we perceive its depth and ambience.

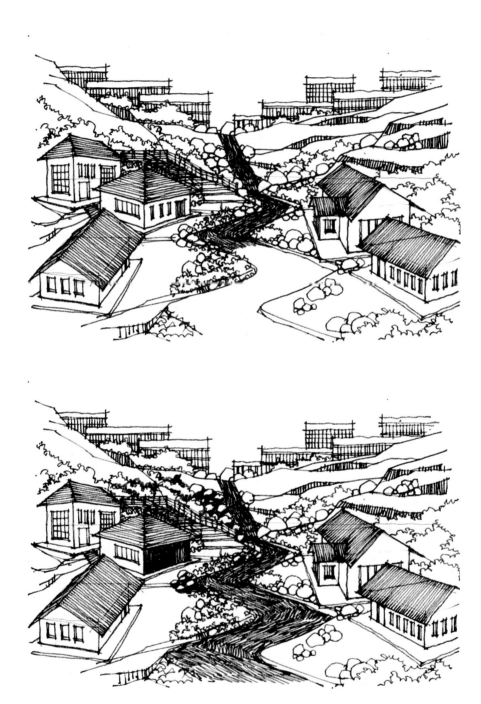

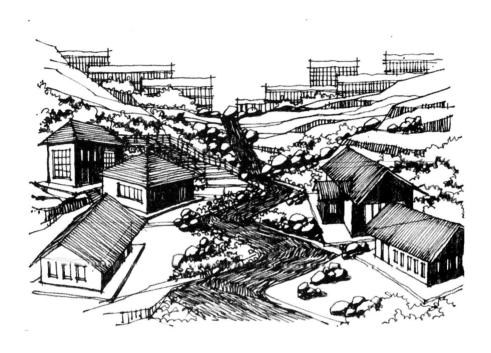

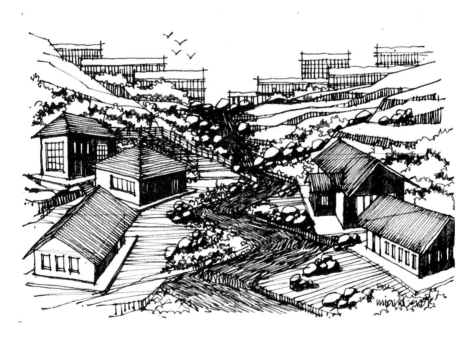

HOW TO DRAW USING AN
ATYPICAL IMAGINARY BOX

Observe the following, especially how this road bend has
been incorporated between the buildings.

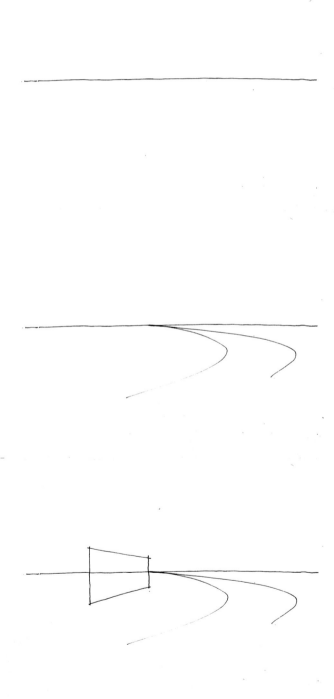

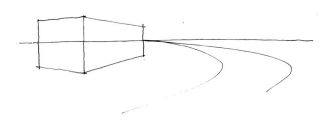

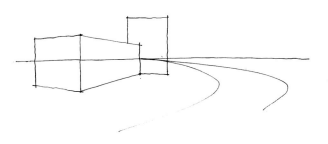

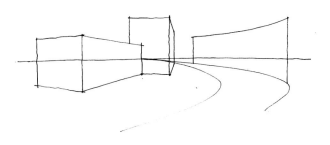

The curved building's form and multi-directional archways may make this composition seem more interesting and complex, but it still remains an easy-to-sketch and easy-to-render piece.

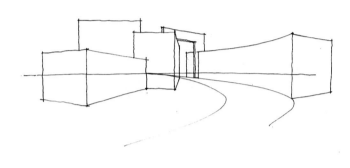

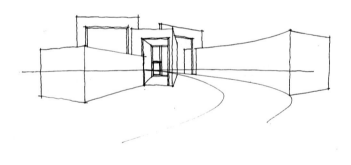

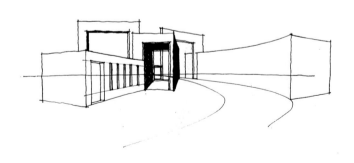

Over time, the mental usage of the imaginary box will guide you in sketching free-hand without having to draw any visible box lines.

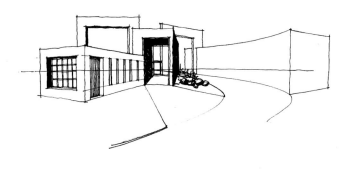

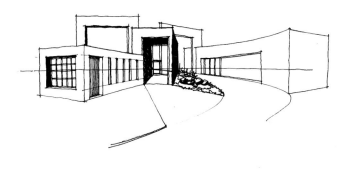

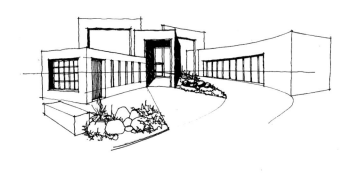

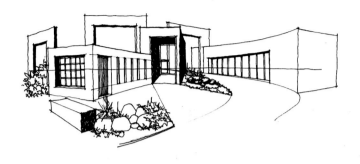

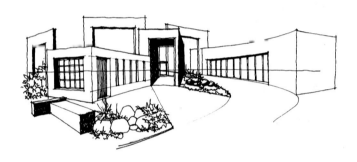

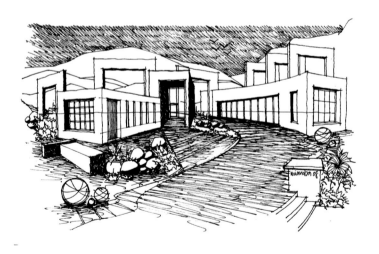

The final sketch after rendering.

REFERENCES

- Mike W. Lin, *Drawing and Designing With Confidence, A Step by Step Guide*, John Wiley & Sons. Inc, 1993.

- Ruzaimi Mat Rani, *The Sacred Garden, Exploration of Garden Design Through Mind Composition*, Pelanduk Publication, 2003.

- Angela Gair, *The Artist's Handbook, A Step by Step Guide to Drawing, Watercolor and Oil Painting*, Abbeydale Press, 1998.

- Francis D.K, Ching, *A Visual Dictionary of Architecture*, John Wiley & Sons. Inc, 1997.

- Kingsley K. Wu, *Freehand Sketching in the Architectural Environment*, Van Nostrand Reinhold, 1990.

- Paul Taggart, *Art Techniques from Pencil to Paint*, Sterling, 2003.

- Paul Laseau, *Graphic Thinking for Architects and Designers*, Van Nostrand Reinhold, 1989.

THE AUTHOR AND ILLUSTRATOR

Ruzaimi Mat Rani graduated with a Master of Landscape Architecture degree from Edinburgh College of Art (ECA), Heriot-Watt University and a bachelor's degree in Architecture from Universiti Teknologi Malaysia (UTM). His interest in sketching, drawing and painting started in primary and secondary school, continuing to higher education levels. His artworks have been exhibited in Bakat Muda Sezaman and PNB Art Exhibition.

His most important artworks are:
- 2003 Collection of 500 pieces of Edinburgh Old Town Sketches.
- 1999 Collection of 85 pieces of the Sacred Garden Collection.

CO- AUTHOR

Ezihaslinda Ngah is attached with Majlis Amanah Rakyat (MARA) as an educator for the subjects of English Language and English for Science and Technology. Throughout her number of years in the education line, she has had the opportunities to serve various MARA colleges. These include MARA Junior Science College (MJSC) Muar, Mersing and currently, Kuantan. She received her early education at Sekolah Rendah Tengku Bariah Kuala Terengganu. She then pursued her lower secondary education at Sekolah Menengah (A) Sheikh Abdul Malek and MARA Junior Science College Kuala Terengganu. For tertiary education, she was offered to continue her studies at Henley College, Coventry, United Kingdom for A-Levels and later her undergraduate degree B.Ed (Hons) TESOL at University of Warwick, Coventry, United Kingdom.